Climate Propagandas
Stories of Extinction and Regeneration

Jonas Staal

THE MIT PRESS
Cambridge, Massachusetts . London, England

*This book is dedicated to iLiana and Roxani,
my gifts of life*

Introduction: How to Analyze Climate Propagandas 1

1 *Liberal Climate Propaganda: Every Extinction for Itself* 31

2 *Libertarian Climate Propaganda: Extinction as Currency* 49

3 *Conspiracist Climate Propaganda: The Extinction Hoax* 73

4 *Ecofascist Climate Propaganda: Extinction Supremacy* 93

5 *Transformative Climate Propaganda: Against Extinction* 113

Afterword: Biostories beyond Extinction 153

Acknowledgments 165

Climate Propaganda Models: Summary 167

Notes 173

*Introduction:
How to Analyze Climate Propagandas*

Performers at the CyberCunt Mini Ball, TRES, Athens, October 5, 2019. Photo: Konstantinos Andrikoula. Courtesy of Konstantinos Andrikoula.

Five Hundred Years of Extinction Wars

A tight-knit swarm of humans have gathered in TRES, a space for music and performance in Athens, their bodies filling the air with warmth and smells of sweat and perfume. At the center of the crowd, a brightly lit path remains where dancers appear in pairs. After receiving a nod from the jury, they begin: the dancers swiftly grasp for oxygen masks out of their costumes. Taking deep, desperate breaths, their voguing motions effortlessly evoke an image of a dystopian world of climate collapse through their intimate, competitive dance.

This is the 2019 CyberCunt Mini Ball, organized by Father Chraja Kareola of the House of Kareola—one of the leading vogue houses in Greece—where dystopian thematic categories, offered for those who wanted to volunteer a performance, include descriptions such as "Oxygen has come to be a luxury only for the rich few. Tell us your own suffocatingly musical story, wearing an oxygen mask in order to be able to survive."[1]

It is a fitting cultural response to the catastrophic present of what scientists call the "Holocene extinction": the end of the relative stability of the geological interval spanning the last 11,500 years from the end of the last glaciation.[2] In popular discourse, this is also known as the "sixth mass extinction," following the fifth mass extinction 66 million years ago that brought the end to the existence of dinosaurs on our planet.[3] Today, this sixth mass extinction manifests in the form of fire tornadoes and plastic tsunamis, tens of millions of climate refugees, raging pandemics, massive harvest failure, logistical collapse, water wars, and other climate crisis–fueled armed conflicts.[4] However, we should already begin to question the use of the term "extinction" here. During the first five mass extinctions humans did not yet exist on Earth; neither did organized human societies and its fossil fuel elites. The sixth mass extinction is the result not of inevitable volcano eruptions or a colliding meteor, but of planetary extractions that benefit only elites at the cost of mass extermination of life forms across Earth. Therefore, we might better understand the sixth mass extinction as an *extinction war*. The reason to call it a "war" is to emphasize that extinction is not a natural occurrence, but the result of the active policies of conquest and domination.[5]

The performances at the CyberCunt Mini Ball show us that in a world plagued by mass climate extermination, different stories need to be propagated through cultures of resistance and defiance, stories of meaningful collective survival and even joy. I will come to discuss these as forms of *transformative climate propaganda*, which imagine and tell stories of reparation and regeneration: imaginaries of life in a world plagued by death. I call these narratives of regeneration *biostories*: stories of the living for the possibility of life against—and beyond—extinction. But to understand the meaning and value of such biostories, I believe we also need to understand the impact of the propagation of fossil fuel–powered dominant stories and imaginaries that have brought the living to the verge of extinction in the first place. Sheena Wilson, Adam Carlson, and Imre Szeman call these mediating forms petrocultures: "the complex and contradictory

ways oil has shaped our social imaginaries and ... the claims and assumptions that shape and guide how we think and talk about fossil fuels."[6] In this book, I will be exploring climate propagandas reliant on petrocultures as they manifest across different ideological spectrums—liberal, libertarian, conspiracist, and ecofascist—all of which refuse divestment from fossil fuel extraction, and leave us to perish in a futureless future.

And the people gathered at the CyberCunt Mini Ball know the threat of forced extinction all too well: as queer, trans, and nonbinary people, their lives have encountered systemic violence and erasure. In the words of Adwait Singh: "To be queer is to be always already born at the end of the world (as we know it) and to put up an audacious fight to continue living at the edge of it."[7] Climate disaster is aided by the reproduction of dichotomies between male and female, humans and nature, in which the domination of one over the other is naturalized and explained as biologically inevitable. Such neo-Darwinist fantasies might claim that men prey on women or that humans seek to control their environment because it is in their "nature." Queer ecologies, on the other hand, in the words of Stacy Alaimo, "resist the naturalization of sex as primarily reproductive and heterosexual."[8] They focus instead on the impossibility of the separation of humans and nature. How can people declare material autonomy from the 39 trillion bacteria that support our bodily systems? This gives testimony to what Myra Hird describes as "the abundant queer behavior of most of the living matter on this planet."[9] From that perspective, the nonbinary family gathered at the CyberCunt Mini Ball embodies a queer ecology that puts Singh's "audacious fight" into practice.

For Indigenous peoples, Black people and people of color, women, the LGBTQI+ community, people with disabilities, and all those on the forefront of emancipatory political struggles, apocalypse has been waged on their communities, practices, and ideals across multiple timescales. As many have pointed out, George Floyd's dying words "I can't breathe," uttered as he was murdered by police officers on May 25, 2020, in Minneapolis, epitomize a history of oppression that goes beyond the killing

Animals made extinct from colonization onward, each termed "comrade" in a different language, some of which are themselves threatened with extinction. Radha D'Souza and Jonas Staal, *Comrades in Extinction* (2020–2021), gouache on paper. Courtesy of the artists.

of a single person. Peoples colonized and enslaved by Empire could not breathe. Plundered ecosystems and their communities cannot breathe. The many in an increasingly toxified world won't be able to breathe.[10] The Silicon Valley tech-optimism that claims quick climate engineering solutions has nothing to offer to a real world that is out of oxygen. In the words of Françoise Vergès: "climate change is not about human hubris, but the result of the long history of colonialism and racial capitalism and its Promethean thinking—the idea that 'Man' can invent a mechanical, technical solution to any problem."[11]

For those like myself who have lived lives of relative privilege in the Global North, the climate crisis is often presented as a new threat that became common knowledge only in the late twentieth century. We are told that climate activists and progressive scientists of the 1960s and '70s effectively pressured governing elites toward bipartisan consensus to curb the impact of extractive industries on our climate, before the propaganda of fossil fuel companies took over and far-right climate deniers

gained the upper hand.[12] But the lived experience of climate collapse goes back much further—not decades, but *centuries*, well before the dawn of the Industrial Revolution.[13] As my collaborator Radha D'Souza has argued, the climate crisis is a colonial crisis.[14] For it is during the rise of European colonial expansion that we witness the first waves of mass extinction of plants and animals resulting from the plundering of resources and enslavement of human communities. Seen in this light, extinction wars are at least 500 years old.[15]

It is in the context of the present sixth mass extinction brought about by centuries of extinction wars that we will analyze the various models of climate propagandas that struggle over the remains of the future: liberal climate propaganda, libertarian climate propaganda, conspiracist climate propaganda, ecofascist climate propaganda, and transformative climate propaganda. But before we do so, we need to talk about terms of engagement. What do we mean when we speak of the climate crisis? How is the climate crisis related to other domains of exploitation and inequality? How does propaganda work, on what (visual) methodologies do we rely to critically engage the models, and on what scale should we apply such models and methods? In other words: How to analyze climate propagandas?

How to Speak, and Who Is to Speak, of the Climate Crisis?

The present moment is often described by geologists and political pundits alike as the "Anthropocene," the geological age of "man": a concept that claims that the human impact on ecosystems due to excessive reliance on fossil fuels such as oil, coal, and gas as well as the greenhouse gases that they emit in combination with mass deforestation has triggered irreversible and disastrous changes to the Earth's biosphere.[16] But this emphasis on "man" suggests that the human species as a whole is inherently extractive, and that the sixth mass extinction is the inevitable result of predatory "human nature." This is a logic beneficial to ruling elites, as it would mean that all humans are somehow

equally to blame for the collapse of the world's ecosystems. It seems more accurate and factual to argue that the climate crisis is the result of what Françoise Vergès terms the "racial Capitalocene": the emergence of an extractive system during the past 500 years that benefits an infinitely small number of elites by turning living worlds—humans, animals, plants, and their bionetworks—into commodities to be bought and sold on ever-expanding markets.[17] It is not the "nature" of humans in general, but the logic of a specific system of colonial and imperialist extraction serving certain human elites that has turned so many living worlds into a single capitalist ruin. Extinction wars aim for the many to perish so the few can thrive.

The idea that the climate crisis is a planetary threat that concerns everyone equally is thus an elite fiction. The reality is that ecosystem collapse is characterized by a fundamentally unequal distribution of apocalypse. Today, extreme weather and its devastating impact on food and living security continue to disproportionately affect people in the Global South and front-line communities of Indigenous, Black, brown, and poor people.[18] There is not a single climate crisis that unites humankind. Rather, the climate crisis makes visible the racial, gender, and class divides that have benefited the extractivist elites who brought the extinction war upon the planet in the first place. Therefore, as T. J. Demos argued, "The challenge is to render these emergencies, catastrophes, and apocalypses as interconnected and mutually informing, centering them with sensitivity by thinking emergencies *together* and collaborating on solutions across difference."[19]

It is in this light that I—a white man from the Global North—will sometimes refer to "us" or "we," even though we all confront a fundamentally unequal distribution of climate catastrophe. I believe it is essential that we acknowledge different pasts, which inform different presents and different futures, shaped by histories of colonialism, extraction, racism, sexism, classism, anti-communism, ableism, and speciesism. But the aim of struggle is to articulate common interests across these inequalities, humans and nonhumans alike. For example, when

we call for the necessity of colonial reparations, this acknowledges the fact that there is something to *repair*—that there are a series of structural, systemic inequalities that divide people. But the aim of this repair—insofar as historical trauma can ever be truly "repaired"—is to shape a new collectivity by practicing solidarity. Practicing solidarity means to have the willingness to organize and fight for egalitarian forms of life, in order to enable a future in which I, or you, or we can honestly say: I know your pain, your loss, your struggle, your victory; I know it like I know my own. So, the "we" I call upon is far from a given. It is a potential we in-the-making that depends on the success of building a planetary popular front across earth workers, both human and nonhuman.

The terms of this struggle are important. For example, the term "nonhuman" is rightfully contested. Why, when we speak of other beings and presences with whom we share our world of many worlds, do we need a term that places them in the negative to the human?[20] Is there no language through which we can address these presences without holding on to an anthropocentric language? Andrés Jaque, Marina Otero Verzier, and Lucia Pietroiusti propose the notion of the "more-than-human" in order "to remind us of how human intelligence finds itself always already interwoven with a multitude of thinking and sensing entities."[21] This includes not just animals, plants, bacteria, fungi, viruses, or protozoa, but also machinic infrastructures with which we have become increasingly integrated in our understanding and navigation of the world. This reality of our more-than-humanness is what "undermine[s] the very possibility of thinking about humanity as autonomous and self-determined."[22]

This is a powerful definition precisely because it articulates the inherent entanglement of the human animal with other beings and presences that inhabit it and with which we live in interdependence. Still, the terms "nonhuman," "other-than-human," and "more-than-human" all attempt to define these entanglements and interdependencies in relationship to the base term "human." In my case, when I use "nonhuman" it is to

speak of "nonhuman animals," to reject the separation between human and animal that upholds a binary that attempts to naturalize human supremacy over its environment. But I will suggest additional terms as well, such as "nonhuman comrade"[23] and, as I have proposed with Radha D'Souza, the term "earth worker," as human and nonhuman animals and plants all work to sustain a biosphere for all.[24] But these are not to replace the terms we just discussed, but rather to add to the vocabulary we need to develop and speak to our fundamental interdependency with other beings and presences: other earth workers.

Ecology of Catastrophe

Although ecosystem collapse is often presented by the elite political class as a separate set of concerns from the economy, military, or welfare, it is in fact deeply tied to wider political, economic, and social systems. Following the work of Radha D'Souza, I already addressed that climate crimes are inherently part of colonial crimes, part of a system that turned living worlds into property. Included in that system of extraction and enclosure are also labor crimes against workers who are forced to survive toxic factories, mines, and other parts of fossil fuel infrastructures. Part of the violence of oil drilling operations is also the poisoning of land on which local communities depend. Climate crisis fuels wars due to food and water shortages, and the millions of refugees who seek shelter are thus equally climate refugees. Furthermore, war crimes are in themselves climate crimes, destroying ecosystems beyond repair, leaving traces of chemicals that torment subsequent generations of humans, nonhuman animals, and plants.[25] Thus, the climate crisis is not a separate issue; rather, it makes clear the entire *ecology* of interlinked inequalities and oppressions that shape the planet—an ecology of catastrophe, which Jason W. Moore describes in terms of "capitalism as world-ecology." He writes: "With capitalism we are dealing with an emergent pattern of symbolic innovation and material transformation in which the value of labor-power,

the rise of world-money, and the endless transformation of the earth form an evolving historical whole."[26]

This ecology—or necrology, as I will argue later on—of the climate catastrophe is what D'Souza and I have tried to confront through our organizational art project *Court for Intergenerational Climate Crimes*: an alternative more-than-human tribunal founded in 2021 that organizes public hearings to prosecute states and corporations for their implications in climate crimes in the past, present, and future. Whereas the existing structure of the law and its regime of rights emerged from the colonial era to legitimize the conquest of land and the living, we propose an alternative legal framework drafted by D'Souza titled "The Intergenerational Climate Crimes Act," which aims to show that climate crimes also always constitute crimes against peoples. As article 3 of the act states:

> An "Intergenerational Climate Crime" is committed when a group of persons acting as a single "legal person" in the name of a legal entity ... engage in acts of commission and/or omission, or engaged in acts of commission and/or omission in the past, that harm or harmed, destroy or destroyed, violate or violated or otherwise adversely impact or impacted the conditions necessary for the reproduction of any species, including but not limited to:
>
> a. Acts of commission and/or omission, in the past and/or present, that harm/harmed, destroy/destroyed, violate/violated, or otherwise adversely impact/impacted upon weather patterns in the short or long term;
>
> b. Acts of commission and/or omission, in the past and/or present, that harm/harmed, destroy/destroyed, violate/violated or otherwise adversely impact/impacted upon weather patterns in an area, as a result of which the survival of non-human species became or has become difficult or impossible;
>
> c. Acts of commission and/or omission, in the past and/or present, that harm/harmed, destroy/destroyed, violate/violated or otherwise adversely impact/impacted

upon relationships of mutual dependence and reciprocity between species or within species, human or non-human; and/or introduce/introduced adversarial relationships between them.

d. Acts of commission and/or omission, in the past and/or present, that displace/displaced people from places, fragment/fragmented communities, and destroy/destroyed cultures.[27]

The Intergenerational Climate Crimes Act is written without once using the word "rights," meaning, without reducing climate crimes to questions of individual harm or individual property that operate along a uneven liberal justice framework. Instead of rights, the notion of "interdependence" is central to the Act, to show that a climate crime never just harms a single species, but impacts the relationships between the living, and the possibility to regenerate the future. When one harms a river through pollution, one does not just harm the river as an individual entity, but all plants, nonhuman animals, and humans who live in interdependency with that river. This is not just a crime against interdependent communities of earth workers in the present, but also against the unborn plants, nonhuman animals, and humans of the future that *could have* lived with the river had it not been polluted.

Thus, we challenge the underlying ideological structure of modern law and its colonial, imperialist, and liberal inheritance, studied extensively by D'Souza, which legitimize climate crimes by turning living worlds into dead property.[28] Let's not forget that the ecocide plotted by the fossil fuel elites that amounts to what Amitav Ghosh terms "omnicide"—or "the extermination of everything—people, animals, and the planet itself"[29]—is entirely "legal," just as colonial powers wrote the law to support theft and enslavement. Law was never on the side of justice. This is why D'Souza and I gather prosecutors, witnesses, and public juries from across the world to perform the *Intergenerational Climate Crimes Act 2021* into being, to testify on different terms against the crimes of the past, present, and future committed by

Surrounded by images of animals made extinct by colonialism, judges, prosecutors, witnesses, and a public jury gather in three cases against the state of Korea and Korean corporations to address the relationship between the military-industrial complex and climate crimes. Radha D'Souza and Jonas Staal, *Court for Intergenerational Climate Crimes: Extinction Wars* (2023), Gwangju Museum of Art, Gwangju. Produced by Framer Framed, Amsterdam, and the Gwangju Biennale Pavilion Project. Photo: Jonas Staal.

states and corporations such as Unilever, ING Group, and Airbus. Through this process, we attempt to put into practice an alternative legal imaginary based on intergenerationality, interdependence, and regeneration. It is an attempt to cultivate a setting for popular justice. To seed, grow, and propagate the alternative institutions and infrastructures to transform the ruins of the fossil fuel world into one that can make stories of regeneration manifest. This is our contribution to the urgency of a transformative climate propaganda.

So, it's not only inequalities that shape different perceptions of the climate catastrophe, but also ideological views: the proprietary capitalist ideology that propagates human-centered modern law is fundamentally different from the intergenerational, interdependent, and regenerational paradigm D'Souza and I propagate. Our perception of climates and their crises, our perception of the ecology of catastrophe, is ideologically structured.

To introduce the cast for this book, let's start with a scenario based on the model of a joke. Instead of walking into a bar, let's say that a liberal, a right-wing libertarian, a conspiracist, a fascist, and a socialist are all looking at a devastating tsunami coming their way. Each of them will see a different tsunami, resulting from their fundamentally different ideological world views. The liberal sees the tsunami as a result of the individual consumer behavior that fuels the climate crisis. The libertarian capitalist considers the tsunami a market opportunity for geoengineering the environment back to stability. The conspiracist will argue that the tsunami is just a scare tactic by the globalist elite: The world is not even round to begin with, how could the climate catastrophe be real? The ecofascist seizes the catastrophe as a chance to argue about who has the racial right to survive the tsunami and who does not. Finally, the socialist points out the unequal origins and social impact of the tsunami on our communities. In other words: "we" don't live in the same world, precisely because we do not see or experience the same climate crisis.[30] Analyzing the ideological narratives that sustain ongoing extinction wars, as well as the stories of regeneration—the

bioimaginaries—that propagate for a world against and beyond extinction belongs to the field of propaganda studies.

How Propaganda Works

The struggle between different worldviews that aim to shape reality plays out in an arena that I describe as a "propaganda struggle." Our interest here is how this arena is occupied by different *climate propagandas*, each of which tries to establish hegemony over the other. Because propaganda is not just concerned with sending a message, its aim is, as Noam Chomsky and Edward Herman famously described in their propaganda model, to "manufacture consent": to construct an entirely new reality structured on a particular ideological worldview of elite interest.[31] Propaganda is not an operation that accepts its place in the world as it is; its aim is *to make a world.*[32]

For propaganda to succeed in making worlds, three components are of key importance: infrastructure, narrative, and imagination.

With infrastructure we can think of the mass media: the means of controlling the distribution of stories and ideas that define a common understanding of the world. Did Trump win or lose the 2021 election? Is Russia Ukraine's aggressor or liberator? Do COVID-19 vaccines work, or do they aim to implant microchips for mind control? Is climate crisis real or a hoax? Is the world flat or round? It is through institutions and media infrastructures that we can introduce what Terence McSweeney terms "master narratives": origin stories—often characterized by collective loss and trauma—about where we come from, who we are, and who we will become.[33] Or, in the case of ultranationalist and far-right narratives, who we are to become *again*, which relates to the Trumpist slogan "Make America great again." Such ideologically driven master narratives provoke an imagination of a world to come, or in the case of ultranationalist propaganda, a world to resuscitate.

Looking at these three components—infrastructure, narrative, and imagination—it becomes evident that propaganda is essentially a *performance* of power: meaning, it is the process through which power shapes the construction of a different reality.[34] Performance has a double meaning here. On one hand, performance describes the way a task or function is put into practice, for example, the task of a particular media outlet to enforce a master narrative. On the other hand, performance has a cultural meaning, like performance in the theater. This second meaning is important because the master narrative of propaganda operates like a script, with reality as its stage, and we are its actors.[35]

Propaganda has been given a bad name. It is associated with manipulation and disinformation, or what is today often referred to as "fake news" as part of the so-called post-truth era of politics.[36] But we should beware such propaganda against propaganda. Constructing new realities—making new worlds—is not by definition only for authoritarians and dictators, as it is also of key importance to liberal and capitalist democracies as well as for popular movements.[37] There is simply no politics without propaganda, but different politics certainly generate different propagandas (in the plural).[38]

The word "propaganda" comes from the ablative singular feminine of *propogandus*, which is the gerundive of the Latin *propagare*, meaning "to propagate."[39] The original use of the word stems from the field of biology, referring to the propagation of plants and animals.[40] In 1622 the Vatican established the Sacred Congregation "de Propaganda Fide," which aimed to spread the Catholic faith against the rise of Protestantism in Western Europe; this was when the understanding of the word began to grow closer to the meaning associated with it today: the organized spread of a particular ideology.[41] But the contemporary understanding of propaganda not just as a form of mass persuasion, but of mass manipulation with devastating consequences, emerges from the First World War. The first modern propaganda bureau was founded by the British at the beginning of World War I. Its headquarters, known as Wellington House,

operated in such secrecy that even elected officials were unaware of its existence, as it used the colonial cable network of the British Empire to manipulate communication in its fight against the Germans.[42] In his diaries, Adolf Hitler speaks in awe of the British propaganda operation that he considered far superior to that of the Germans, and he would later model his own Nazi propaganda ministry headed by Joseph Goebbels on that model.[43] But, as Jonathan Auerbach and Russ Castronovo argue in the first of their thirteen theses on propaganda: "Propaganda is not intrinsically evil or immoral." They continue:

> [The] virtually automatic commonplace that propaganda is inherently dishonest and deceitful emerged directly from the practice of propaganda itself, specifically the charges and counter charges made between Germany and its enemies during and in the aftermath of World War I. Yet the existence of the concept and practice of propaganda prior to the Great War for nearly three hundred years suggests a more benign history, with the concept linked to mass movements such as suffrage, the abolition of slavery, and environmental conservation.[44]

In other words, it is also possible to narrate another propaganda history from the perspective of popular mass movements and organizations that resisted religious doctrine, colonial Empire, and the rise of fascism. With socialist movements emerging across the world in the early twentieth century, Upton Sinclair described propaganda as a collective endeavor to "make a world" liberated from the shackles of feudalism and capitalism.[45] W. E. B. Du Bois spoke of the importance of "black propaganda" in the civil rights and Black liberation movements, in order to propagate the reality of the struggles of Black people and people of color in the face of white supremacy.[46] In relation to the struggle for environmental justice, Donna Haraway addressed the importance of propaganda to make visible the diverse realities of human and nonhuman ecosystem workers.[47] Lucy Lippard spoke to the importance of "intimate feminist

Donna Haraway propagates multispecies coalitions in Fabrizio Terranova (dir.), *Story Telling for Earthly Survival* (2016), still. Courtesy of Icarus Films.

propaganda as a way to build tight-knit communities that could resist dominant patriarchal propaganda.[48]

Thus, emancipatory politics also use propaganda to construct new realities, to make worlds, structured on principles of equality, justice, and collectivity, and aims for the democratization of society in defense of collective interests. When I discuss transformative climate propagandas, the propagation of stories of regeneration (biostories) later on, knowing of this emancipatory heritage of propaganda is essential. For transformative climate propaganda continues to expand on this long but under-theorized history of emancipatory propagations.

Already in this short summary, the meaning of propaganda changes depending on ideology. The Vatican, the British, and the Nazis all used it, but it would be bizarre to claim that these propagandas were all the same. That is even more so the case for the role of propaganda in social, civil rights, Black liberation, feminist, or climate justice struggles. Different forms of power, and different ideologies, generate different propagandas, each aiming to perform power to construct their own reality, their own world. And this is equally the case for the struggle between climate propagandas that aim to shape the future—or the final undoing—of the biosphere.

Climate Propagandas

We will look at the different worlds that are propagated from the climate crisis through the lenses of different ideologies, from liberal climate propaganda to right-wing libertarian climate propaganda, from conspiracist climate propaganda to eco-fascist climate propaganda, and finally transformative climate propaganda, which is concerned with propagating biostories: stories of regeneration against and beyond extinction. Each chapter is an attempt to inhabit the master narrative of one of these climate propagandas, the core stories it tries to tell, and the imagination of the world it tries to realize, as well as critical theory and fiction that demonstrate what those stories and

worlds may look like. Together they shape the arena of today's climate propaganda struggle: various competing propagandas, each of which aims to construct reality based on its interests and ideological views.

In the process I will focus specifically on climate propaganda *narrative* and *imagination*, through a wide set of examples from the field of (popular) culture, including film and television, literature and art, architecture and design. This interdisciplinary approach is important because propaganda never operates through a single cultural phenomenon or medium alone, but through as many forms as possible to construct a new reality. Thus, my exploration will aim to capture the cultural imaginaries of climate propagandas in the broadest sense as they operate in the context of today's extinction war.

This approach to developing propaganda literacy in the context of the climate crisis is indebted to the field of visual culture studies in aiming to achieve a form of visual literacy of the way that narrative and imagination operate to construct new realities. This is the domain of morphology, the genealogy of form that forms our world, which attempts to not simply interpret form from an external position, but to *read form through form*.[49] This demands a shift described by W. J. T. Mitchell as a need for "picture theory" that challenges the Western dominance of verbal discourse over visual representation.[50] In this approach, we move from an understanding of the world-as-text to the world-as-picture in the context of the hyper-stimulus of modern visual culture from the nineteenth century to the present day, in which, in Nicholas Mirzoeff's words, "visual culture does not depend on pictures themselves but the modern tendency to picture or visualize existence.[51] And this acceleration of "the global flow of images" is, according to Marita Sturken and Lisa Cartwright, "subject to intense economic, legal, and political power struggles," which I described earlier as the propaganda struggle.[52]

To learn to read relationships of power in our hyper-mediated environment, then, means that we need to navigate an accelerated field of morphology across a vast set of imaging disciplines—from visual production in popular media to contemporary art

Several thousands of people took to the streets, called by organizations such as Extinction Rebellion, Greenpeace, Youths for Climate, Attac, and ANV-COP21, to urge French presidential candidates to take into consideration the climate emergency. This protest was called "Look Up" in a reference to the film *Don't Look Up*. Toulouse, France. March 12, 2022. Photo by Alain Pitton/NurPhoto.

and science, and the various intersections between them. This is why I chose to open this introduction and various segments of the coming chapters not through the description of a specific image related to a propaganda case study—starting with the CyberCunt Mini Ball—but through an immersive narration of their experiential and affective modus operandi: the image *and* the experience of the world it aims to propagate.

While each of the chapters is dedicated to a specific type of ideological climate propaganda, the examples used in some cases might also be applied to another. Take a film like *Don't Look Up* (2021), directed by Adam McKay, which follows two scientists who alert a Trump-type president in the United States of an enormous meteor on track to destroy all life on Earth. The initial government response is that of alt-right denial, mimicking the conspiracist denial of the reality of climate crisis, or the denial of vaccines being effective against the COVID-19 virus: "Don't vaccinate" becomes "Don't look up!," for if you don't *see* the meteor,

then it does not exist. But following the initial Trumpian government's disengagement from the existential crisis heading Earth's way, an Amazon-styled tech corporation called BASH steps in with a plan to mine the meteorite for rare minerals and turn the coming disaster into a market opportunity.

Both examples—the denial of the meteor's existence (the Trumpian view), and the attempt to profit from it (the corporatist view)—illustrate two ideological perspectives motivating the production of two distinct climate propagandas that I will discuss in the coming chapters: conspiracist and libertarian. But we can also look at the intended liberal, Netflix-subscribed audience of the film, that will tend to identify with the two scientists desperately trying to warn a world plagued by misinformation about the coming threat.[53] Their apparent "apolitical" voice of scientific reason comes closer to what we will discuss as liberal climate propaganda. Thus, a single film can benefit from different, parallel propaganda analyses. The main question in researching propaganda is always which overall master narrative it supports more than any other, and perhaps how one propaganda feeds into another. Thus, different categories of climate propagandas that I will introduce are meant to distinguish various dominant ideological strands in the mediatic and cultural struggle over the climate crisis, but some categories will overlap, or even work as *gateway propagandas* for one another. For example, we will see how it is easy to radicalize from conspiracist to ecofascist climate propaganda.

The Question of Scale

The choice to focus on the narrative and imaginative component of different climate propagandas does not mean that the first of three components in propaganda analysis, infrastructure, is not of relevance. Without the institutions or media networks necessary to disseminate a narrative and imaginaries, there would be no propaganda in the first place. Propaganda aims to manufacture consent; and to construct a new reality,

one needs to communicate and mobilize the people to perform that new world into being.

As in all instances of political organization, a difficult question that returns in propaganda studies is that of scale. When does an effort to disseminate a narrative and construct a new reality take place at such a scale that the term "propaganda" becomes applicable?[54] When a family fiercely debate their pro- and anti-Trumpian views at the kitchen table, each of the participants propagates, but not at a scale that is generally considered to warrant an entire propaganda study. It might be relevant, rather, for the discussion to be viewed as a micro-performative dimension of propaganda. If the Trumpian mass campaign to shape a new authoritarian government is the macro-performative dimension of his propaganda, the micro-performative dimension relates to the way people are affected by his narrative and imagination of a lost American greatness and are willing to propagate his message in their intimate environments. The macro-performative dimension of propaganda does not work if people are not willing to adopt and perform its attitudes and convictions in the intimate daily settings of the theater of propaganda: the home, the workplace, the classroom.

Scale is relative to context. For a neighborhood campaign to save a park from becoming a shopping mall, the scale of the park and its surrounding communities is the scale of propaganda that matters. For a stateless nation to become a state, it's the scale of the nation and its peoples as well as other existing states that might provide further recognition. Furthermore, as Lucy Lippard notes in her proposition for an intimate feminist propaganda, the predominant male involvement in propaganda production and study may have created a bias to particular masculine notions of scale and power in the first place. As Lippard remarks, propaganda "acquired its negative connotation in a colonializing male culture (e.g. the Roman Catholic Church),"[55] laying the foundation for the dominant "patriarchal propaganda" that clearly haunts even propaganda studies itself.[56] And indeed, when men take to propaganda and the climate crisis, projects propagating mass climate engineering and

terraforming efforts are all too common: problems at the scale of the world are responded to with solutions at world scale.[57] But are these obsessions with power as scale not embedded in the emergence of climate catastrophe in the first place? Is the climate crisis not a continuation—a further propagation—of the colonial, imperialist, and capitalist gaze that turns a world of many worlds into a singular managed globe?

In the work of feminist artists of the 1970s, their interdisciplinary explorations ranging from performance to video, music, poetry, discussion panels, consciousness raising, and even meetings and small-scale assemblies, Lippard recognizes the power of a different kind of propaganda. The intimate propagandistic power of the spoken word:

> The spoken word is connected with the things most people focus on almost exclusively: the stuff of daily life and the kind of personal relationships everyone longs for in an alienated society. It takes place *between* people, with eye contact, human confusion and pictures (memory). It takes place in dialogues with friends, family, acquaintances, day after day. So one's intake of spoken propaganda is, in fact, the sum of dally communication.[58]

And Lippard concludes: "This more intimate kind of propaganda seems to me to be inherently feminist."[59] This is a fundamental intervention in the field of propaganda studies, centering a propaganda on the most intimate micro-performative scale, the space where affective and thus effective bonds are established, essential to organizing feminist counter-power. The way that Lippard challenges the affect and effect of different scales of propaganda is important to keep in mind in the climate propaganda case studies we will be discussing in the coming chapters. You will encounter many different infrastructures in which propaganda narratives and imaginaries circulate. In some cases, you might not challenge their relation to scale, in the sense that they "feel" big. Popular Netflix documentaries such as *My Octopus Teacher* or *Our Planet* have audiences in the millions. Trump

tweeting an ecofascist video produced by the Trump War Room has an instant impact on his masses of followers. The infrastructural reach and economic impact of tech trillionaires Elon Musk's and Jeff Bezos's space colonization programs and terraforming missions defy imagination. And, to a lesser extent, I believe most will accept that the reach of the emancipatory science fictions of Octavia Butler and Kim Stanley Robinson or of the Indigenous science fiction film *Night Raiders* is substantial. Although these scales of impact and their audiences are quite different, they all feel sufficiently "large" for a reader not to raise eyebrows when the term "propaganda" is applied to them.

With examples from the field of critical art and culture, this might be less obvious. In the closing chapter on transformative climate propaganda, in particular, we will encounter examples of artists using their imaginative competences to build and defend autonomous zones, use performative strategies in popular climate protests, or infiltrate natural history museums to challenge—and alter—their dominant institutional narratives. These might seem smaller in scale, more intimate in their form, less capable to instantly access the millions of Netflix subscribers or millions willing to reelect Trump to ensure there will never be elections again. But especially in these seemingly small-scale examples, Lippard's intimate feminist propaganda model is critical for understanding how scale can equally build from the intimate to larger social organizations and movements.

The Afrofuturist video work of Charl Landvreugd, for example, might circulate mainly in the context of art institutions, educational frameworks, and online viewings by a more specialized audience. But his work, which propagates identitarian hybridity across different scales of time, cannot be separated from larger political and cultural movements of anti-colonialism and decolonization. And considering that Landvreugd is also the first artist to lead the curatorial research of a major institution, the Stedelijk Museum in Amsterdam, he shapes infrastructures of circulation at a scale that the intimacy of a video might not reveal instantly. And most of all, there is the scale of

worlds that become possible to *imagine* through his work: reality is made from the worlds that we can image. In other words, with Lippard in mind, we should not mistake the intimate for the marginal. Possibly, the intimate is the largest imaginable scale to propagate genuine transformation.

Becoming Part of the Storm

The closing chapter on transformative climate propaganda is the longest by far. While I believe it is essential to analyze the dominant climate propagandas that threaten the future of our ecosystem, understanding propaganda on its own does nothing to stop it. You can throw as many climate science reports into the debate, but facts in and of themselves change nothing. Facts need narratives, stories, and imaginaries to be *affective*, and therefore *effective*. We cannot leave the propagation of our world to the tech giants and ecofascists who aim to dismantle what remains of the planet for their ecocidal interests. We need a transformative propaganda of our own that appeals to collective desires for intergenerational justice, colonial reparation, and societal transformation. These are the regenerative biostories emerging from the CyberCunt Mini Ball and many other cultural forms of resistance I will discuss in detail: the stories of life that resist and aim to overcome extinction wars.

You might wonder why liberal, libertarian, conspiracist, and ecofascist climate propaganda each get a chapter of their own, whereas highly diverse propagandas emerging from progressive, democratic-socialist, Indigenous, Afrofuturist, and queer movements are all grouped into the single category of transformative climate propaganda. Why not dedicate a different chapter to each of them? Part of the answer is that the preceding chapter on conspiracist climate propaganda also contains subcategories: flat Earth climate propaganda overlaps but is not exactly the same as antivaxxer climate propaganda or Querdenken climate propaganda. One could potentially dedicate separate chapters to each of these as well. The reason for the groupings points to

the fact that one can speak of shared propaganda infrastructures, narratives, and imaginaries. In the case of transformative climate propaganda, there are egalitarian desires that link the different examples, but the more important reason for grouping them is their coalitional stance: the desires expressed in each to establish broad popular fronts or earthly defense, survival, and collective transformation.

Considering we approach the climate crisis as a colonial crisis resulting from 500 years of extinction wars, the concept of decoloniality lingers through many of the examples in transformative climate propaganda as a possible coalitional paradigm. In the words of Walter D. Mignolo and Catherine E. Walsh:

> Decoloniality denotes ways of thinking, knowing, being, and doing that began with, but also precede, the colonial enterprise and invasion. It implies the recognition and undoing of the hierarchical structures of race, gender, heteropatriarchy, and class that continue to control life, knowledge, spirituality, and thought, structures that are clearly intertwined with and constitutive of global capitalism and Western modernity. Moreover, it is indicative of the ongoing nature of struggles, constructions, and creations that continue to work within coloniality's margins and fissures to affirm that which coloniality has attempted to negate.[60]

And the stories of these "struggles, constructions, and creations" hold power. Importantly, they have the power of forging memory, and one of the most terrifying aspects of the sixth mass extinction is that it destroys the collective capability to remember. The perpetual crises that extinction wars will continue to unleash in increasingly accelerated form deny us the time to think or to mourn. But our stories must continue to be told. Not just the story that teaches us that the extinction wars waged against us are a colonial inheritance, but also those that historicize and commemorate the countless forms of resistance and regeneration that are part of peoples' history and heritage.

The power of stories is both terrifying and hopeful. Terrifying in how authoritarian and extractivist forces have gained the upper hand by propagating the master narratives of the extinction wars that lay ruin to our world: the predatory master narrative of the dog-eat-dog world, the white supremacist narratives that declare who has the racial right to survive the climate catastrophe and who does not, and the fossil fuel narratives of endless growth in a world that can take no more. But I'm always reminded of the fact that the reason why we can articulate words such as "equality" or "justice" without ridicule is an inheritance of those who made these words imaginable and actionable. Much of our emancipatory heritage, such as ideals about equal access to healthcare and education, social security and colonial repair, redistribution and equal political representation had to be imagined, narrated, and struggled for to become possible realities. The propagation of all such biostories is like time seeds: we harvest the ones planted before us, and then plant our own to propagate future worlds into being. Stories are intergenerational and interdependent. We never tell them on our own; we propagate them collectively.

We can, and we must, tell stories of life old and new that do not just fight climate change, but also enable us to *change with the climate*. A storm has been unleashed upon us, but we can become part of this storm to change its course: not to return to a nostalgic world past, but to seek for collective transformation toward worlds of care and repair, of degrowth and redistribution.[61] A world regenerated in which we recognize humans, nonhumans, and other-than-humans as fellow ecosystem workers, as comrades even! Earth workers united in an existential struggle against the death-world of colonial extraction, and in defense of living worlds and deep futures for all.

Red Specter (2020–2021). The storm of climate catastrophe reveals a red specter of repair and regeneration rising from a mountain ridge. Digital painting made by the art and activist collective Not an Alternative.

1 *Liberal Climate Propaganda: Every Extinction for Itself*

Betraying Comrade Octopus

Craig Foster, a burned-out documentary filmmaker, begins one of his daily free-diving sessions in a kelp forest in the sea nearby his Cape Town home. There, he encounters an octopus and starts following them during its swims. Slowly, the octopus shows mutual curiosity, and Foster becomes acquainted with their daily routines, their shape-shifting behaviors, and the architectures of shells, stones, and animal bones that form their habitat. In his words, an "intimate friendship" develops that breaks down the abstraction of nature, turning it into an intimate home: Foster describes how he begins to feel part of the oceanic world through the relationship with the octopus, which he considers simultaneously teacher, friend, and lover.[1] That is, until the octopus is attacked by pyjama sharks. First a shark bites off one of the octopus's arms, leaving them with months of recovery. After the octopus engages in a final mating act and leaves their eggs to the future, another shark rips apart

Craig Foster reenacts his "love story" with an octopus in Pippa Ehrlich and James Reed (dirs.), *My Octopus Teacher* (2020), still. Image: © Netflix/Entertainment Pictures.

their deceased body. All this time Foster observes. He wishes not to interfere, for this, he argues, is the cycle of nature. In reality, it is a terrible betrayal.

In the Oscar-winning film by Pippa Ehrlich, James Reed, and the Sea Change Project, *My Octopus Teacher* (2020), these scenes are graphically depicted in Netflix HD. Ehrlich and Reed claim to tell a story about a human reconnecting to the broader ecosystem Foster is a part of. Through the octopus, Foster is no longer a mere observer of nature, but comes to recognize himself as one among many interconnected nodes in a complex system of living worlds and intelligences, human and nonhuman alike. In so doing, he anthropomorphizes the octopus: when they hold him with their tentacles, it is interpreted as an intimate, even sexual act. For him to understand them, he must turn them into a human, rather than acknowledging their intelligence on its own merits.[2] And when they are attacked by sharks, when their bond, their supposed friendship, is truly tested through the aggression of another being, he externalizes himself instantly. He refuses, in his own words, to "interfer[e] with the whole process of the [kelp] forest."[3] Now the octopus is no longer a loved one who demands him to act, to protect; no, the octopus is nature again, and thus, the octopus is destined to die, while Foster lives. The octopus was his self-help tool, a mere sacrificial character in his self-imposed wellness treatment, that helps Foster tell a false story to himself and viewers of the film about the cyclical nature of life and death. His burnout now transposed to their ravaged body, he leaves the ocean, renewed. A human leaving nature.

In short, Foster, a white man in a country that carries the brutal history of colonization and Apartheid, does what the white man does. Like all colonizers, he is in awe of the wild, of its supposed violence and, simultaneously, of its innocence. Oh, the noble savages—ancient tribes and erotic octopus alike—driven by mysterious instinct and ritual! They are nature, and he relishes in their sublime. But they do not carry the burden of history, for that is the white man's cross to bear: to understand the world, to subject it to his will and interests through extraction, murder, domination, and enslavement, but to never be a part

of it.[4] Were Foster to act true to his own words, he would have defended his octopus teacher, friend, comrade, from attack. He would have acknowledged that there is no nature external to him, no cycle that is not shaped by the choices and intelligences of either octopus or human. He would have acted on the bonds among fellow earth workers, for it is these bonds that make nature.[5] But such an understanding, such a practice, goes counter to his interests and established privilege: others must die for him to live.

This colonial mindset enables a highly individuated perception of human relations to ecosystems. Foster has no need to genuinely consider the octopus as a comrade or himself as a fellow earth worker. Neither does he need to reflect on the historical inequalities of his country or his own whiteness. His midlife burnout takes central stage, consuming all attention from the histories that enable his privilege. It is here that we encounter the fundamental *liberal* component in liberal climate propaganda: the individualization of nature.

Empire's Voice

A liberal climate propaganda is a propagation that always reduces the reality of our interdependent world to the individual, while maintaining a fundamental division between people and "nature." It combines guilt over so-called human nature with a sense of benevolent, enlightened superiority. Think, for example, of the documentary series *Our Planet* (2019), narrated by Sir David Attenborough, who has increasingly been cast as the present era's wise climate conscience. As he has done for decades, Attenborough's voiceover celebrates pristine nature and its cycles: exuding paternalistic joy when birds perform peculiar mating rituals, then becoming solemn when an antelope is ripped apart by lions. In recent years, his voice has become the voice narrating climate collapse, and the danger that "we"—all humans in his conception—pose as he exposes his viewers to generic clips of melting icebergs and drowning

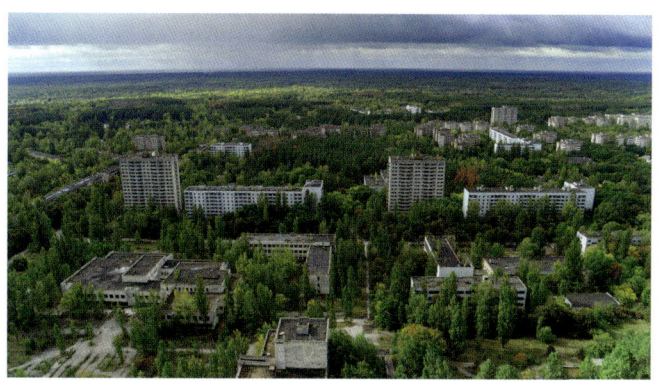

Animal and plant repopulation of Chernobyl in Alastair Fothergill (dir.), *David Attenborough: A Life on Our Planet* (2020), still. Courtesy of Altitude Film Entertainment/Silverback Films/Album.

polar bears. Footage of the animal and plant repopulation of the Chernobyl nuclear site is used to drive home his point: when humans retreat from nature, even heavily contaminated sites reforest themselves within only a few decades, allowing wildlife to reappear.

Attenborough is rarely visible in person, manifesting predominantly as a god-like voice with a bird's-eye view, a benevolent voice of reason. His accent is the proper English, that of the Empire. It is ironic given that while the English convinced themselves throughout colonial modernity that their task was to civilize, it was precisely the construction of their Empire that shaped the colonial and industrial foundations of the current ecosystem collapse.[6] This will to civilize and tame continues with Attenborough as he narrates footage taken by high-res cameras that penetrate ever deeper into remote forests and seas, extracting images of highly endangered species. Although it is relevant to note that the increased visuality of this type of documentary goes hand in hand with an actual reduction of factual data and research about the species displayed if we contrast it to, say, the comparatively low-res but high data film productions of the 1960s and '70s.[7] The territorial British Empire might have

crumbled, but its gaze, now directed through an army of submarine and drone cameras, still reaches into the far corners of our planet, always accompanied by that authoritative British voice that tells listeners how history began, how it will end, and how it can be saved. Extinction televised.

Attenborough's *Our Planet*, like *The Octopus Teacher*, does not challenge the historical roots of his own gaze. Instead, he combines the colonizer's guilt with the colonizers' sublime: in awe of nature, in shame of what "we"—generic humanity—have done to "it."[8] And when it comes down to the question of climate action, of what is to be done, it is humans and not systems—not fossil fuel CEOs and other climate criminals—who are to blame for the climate catastrophe. Instead, "we"—a certain population of human individuals watching the program—pose a threat to the natural world, "we" must give forests the time to repopulate, and "we" are the origin of our own extinction. Not the fossil fuel elites who have left us a collapsing world but *your* lightbulb, *your* plane tickets, *your* shopping carts, *your* holiday are to blame. And so, nature suffers. For within the logic of this reasoning, humans do not belong to nature. No, nature is external, a resource primed for extraction. Or it is a resource for the last contemplations of an empire on the brink of the very collapse it brought about?

This means that in liberal climate propaganda—despite calling upon a generic "we"—it's really every extinction for itself. While extinction processes are empirically seen to be the result of vast extractive predatory systems shaped over centuries, and while they empirically affect vast communities of humans, nonhuman animals, and plant life, in liberal climate propagandas their meaning is always reduced to the point of view of the individual, and the individual's own conscience and benevolence. The myth of "green consumerism" responds directly to this narrative: dirty capitalism produced by human consumers brought about the crisis; environmentally conscious capitalism can turn the tides. For a mere few euros, you can book plane tickets that "carbon offset" the environmental damage that results from that very same plane travel.[9] Tesla electric cars provide a sleek

futuristic design bonus for those willing to abandon internal combustion engines. Endless variations of eco-quality marks enable us to assuage climate guilt in supermarket chains.[10] The reality is that so-called green capitalism equally relies on massive extractive industries and subsequently does nothing to undo the social misery of its precarious work forces, which is subsequently compensated with additional greenwashing exercises, to the point that even the military industrial wing of Airbus now promotes "green warfare," presenting carbon-neutral drones and electric Tomahawk helicopters in its glossy sales pitches.[11]

Lonely Climates

Because liberal climate propaganda individuates collective crises, it generates profound loneliness, with devastating psychological costs as a result, maybe best exemplified by the album *Songs of Disappearance* (2021) featuring the sounds of endangered birds that soared to the top five of most-listened-to Christmas albums in Australia.[12] To witness and bodily experience dying worlds, and to have the responsibility of this extinction process entirely placed on oneself as a sole individual, left with "green" consumption as the only actionable scenario, is schizophrenic.[13] This is one of the most powerful aspects of Greta Thunberg's activism, who, as has now been recounted many times, could not reconcile her high school education preparing her for a future world with the reality that this same world was disintegrating before her. She understood that teaching one how to live in a world that will soon cease to exist is utterly violent.[14] Her initiation of a climate strike by sitting in front of Swedish parliament with a sign declaring "School Strike for Climate" was a rejection of this violence by opening a space for collective action, which contributed to the worldwide Fridays for Future movement, in which millions of young people left their schools once a week to take to the streets.

It is telling, in that light, that liberal climate propagandas such as Nathan Grossman's documentary *I Am Greta* (2020),

which follows Thunberg on her international low-carbon travel to campaign against the current mass extinction event, does not substantiate her public speeches and lectures with evidence of climate catastrophe, or show her as part of a larger network of climate activism and organizing. Instead, Grossman turns the film into a personal testimony of Thunberg's own fears and doubts—fears that are all too familiar for many people facing climate catastrophe—highlighting her neurodevelopmental disorders, more than her contribution to larger collective struggles toward climate justice. As such, his film is reductive in a similar way as was the painful act of mainstream media's removal of Vanessa Nakate from a group photo with Thunberg at the 2020 Davos summit. Nakate had sparked her own climate uprising after protesting alone for months in front of the Ugandan parliament, subsequently founding Youth Future Africa and the Rise Up movement, and had been the only Black and explicitly anticapitalist climate activist from the Global South present in the original picture with Thunberg.[15] Reducing system crisis to white individuals from the Global North literally erases from view the larger histories of inequality that produce climate crisis in the first place, negates the struggles in the larger climate movement, and produces the inherent sense of loneliness and mental toll that climate grief poses to wide parts of our population. This is what I will refer to as "climate loneliness" throughout this chapter.

That effect is equally achieved by well-intentioned projects such as *Extinction Claims* (2021) by artist Paulo Ciro. His project builds on the Rights to Nature Movement, which calls to expand the frameworks of human rights to include nonhuman beings and ecosystems; its landmark was the 2008 decision by Ecuador to formally recognize and implement the Rights of Pachamama (Mother Earth) in its constitution, declaring in Article 71:

> Nature, or *Pachamama*, where life is reproduced and occurs, has the right to integral respect for its existence and for the maintenance and regeneration of its life cycles, structure, functions and evolutionary processes. All persons, communities, peoples and nations can call upon public

authorities to enforce the rights of nature. To enforce and interpret these rights, the principles set forth in the Constitution shall be observed, as appropriate. The State shall give incentives to natural persons and legal entities and to communities to protect nature and to promote respect for all the elements comprising an ecosystem.[16]

Ciro's project follows less the Indigenous Quichua principle of *sumak kawsay*, or "buen vivir" (good living), that forms the foundation of Ecuador's constitutional expansion, but rather propagates a liberal quantified approach through an online database that unleashes an algorithm to calculate "justified claims" for financial compensation of different species.[17] On Ciro's website, the Amatola toad and Asian narrow-headed softshell turtle are depicted as potential plaintiffs and are calculated to have the right to demand financial compensation from major fossil fuel criminals, like China Coal Energy or Exxon Mobil. Ciro employs the liberal logics of individual responsibility and compensation as answers to a collective crisis, calling on the public to "Claim a financial compensation from major fossil fuel firms to preserve this species."[18] The Amatola toad might become a rights-bearing subject in this context, but still needs to be benevolently "preserved" by a human bringing the case forward.

While we might wonder how much the toad or turtle cares about the cynical idea of financial compensation, we could also ask whether fossil fuel giants actually care about having to pay them considering that the costs of lawsuits are nothing but a fraction of their net income.[19] Such a liberal take on "reparation" centers on the proprietary form of money, and is unwilling to acknowledge that this logic is part of the profit model: as long as you pay a symbolic sum to those whose livelihood you destroy, extraction can continue as usual. *Extinction Claims* does not change climate loneliness; rather, it expands it, from the lonely human to the lonely toad. And in the meantime, fossil fuel companies and other climate criminals want nothing more than for everyone to feel like powerless individual consumers, and for our collective stories of resistance to be told as if they

Olafur Eliasson's *Ice Watch Paris* (2015), Place du Panthéon, Paris, installed during the 21st Conference of the Parties (COP21) held in Paris from November 30 to December 11, 2015. EPA/Guillaume Horcajuelo.

were mere personal testimonies, or for their cynical "compensation schemes" to be adopted as if they were actual solutions.

Another such project that enforces climate loneliness while providing compensation schemes at the same time is Olafur Eliasson's *Ice Watch* (2015), developed together with geologist Minik Rosing, which consists of twelve large blocks of ice that were extracted from a fjord outside Nuuk, which is publicly known as "Greenland" but is actually Kalaallit Nunaat, land of the Kalaallit, also known as the Greenlandic Inuit. The blocks were placed in a circular formation on the Place du Panthéon in Paris, melting away during the COP21 climate summit, while Eliasson simultaneously called the public to join in support for his *Little Sun* (2012) project: a solar-driven lamp developed together with "communities, businesses, civil society, and governments" to bring light to the Global South.[20] On one hand, the artist cynically stages climate collapse, forcing the climate lonely crowd to witness what "they" have done to our ecosystem. On the other, he provides a consumerist solution in the form of miniature solar lamps for the so-called Third World, which stand

in no meaningful relation to the scale of the climate catastrophe whatsoever, and are created together with the same businesses and governments that are responsible for the crisis in the first place. The very same governments and businesses that have since proven unwilling to act on the already flawed Paris Climate Agreement to which Eliasson's work formed the cynical décor.

Recognition without Recognition

Rendering the causes of systemic crisis as individual responsibility or reducing the experiences of those crises to individual identities generate a type of recognition of climate crisis without addressing either its root causes or the necessity of a collective, organized response. It is a "recognition without recognition," one could say, an acknowledgment of climate change without system change.[21] While it is easy to point to the latest generation of authoritarian leaders and regimes that have made climate denial a hallmark of their murderous policies, it is not in fact the Trumps and Bolsonaros, the Modis and Putins, who laid the foundations for this crisis in the first place. It's exactly the supposed liberal, middle-of-the-road establishment that lines the halls of congresses and parliaments throughout the world; they are the ones who have enabled the normalization of climate criminality as a fact of life, and that continue to pretend that moderate consumer-led "green" reform will somehow be enough to avoid ecocide.

Liberal climate propaganda sustains this recognition without recognition in various ways. It pervades the third season of the TV show *The Good Fight* (2017–present), the wokewashed sequel to the ultra-white *The Good Wife*, now set in a majority-Black Chicago law firm built by a veteran of the civil rights movement. Throughout the season, lawyers from the firm take on judges and alt-right agitators connected to the Trump regime, while trying to maintain a steady cash flow from their high-net-worth clientele. Extreme weather features in several episodes of its fourth season, culminating in a final episode where

a "lightning ball" threatens the city. Nonetheless, not a single lawsuit brought by the firm addresses the urgency of the climate catastrophe manifesting right outside the windows of their firm, nor the firm's deep implications in the liberal establishment that have continued to let the fossil fuel industry come off unscathed. Instead, extreme weather is simply reduced to a metaphor for the extremity of the Trump regime. Once we return to the liberal "normal," extreme weather will somehow disappear as well, the show seems to say, thanks to green capitalist soy cappuccino sipping, and an extra dollar per plane ticket to carbon-offset our collective consciousness to oblivion.

A similar recognition without recognition haunts the TV series *The Affair* (2014–2019), which follows the extramarital affair of Noah Solloway, a New York writer in the throes of a midlife crisis, with Ruth Wilson, a waiter who works in a diner near his Montauk vacation home traumatized by the loss of her drowned daughter. Its final season is set in a climate catastrophe–ravaged world, where automated smart homes regulate oxygen levels and grow food kits in case of shortages, and sleek electric trains travel back and forth to the coast when floods are low. The series depicts the elderly Solloway nostalgically dwelling on the streets of a near-abandoned Montauk, as well as Wilson's second daughter, Joanie, who works in the area as a coastal engineer. It is Joanie who realizes through researching the rising tides that Montauk has not more than five years left before being swallowed whole by the rising sea. But although the coast is disintegrating, none of the characters seem to care about the ecosystem collapse happening before them, except as a metaphor in which an unraveling world mirrors the unraveling of a past marriage, and a drowned sister. Planetary trauma remains voiceless, except as allegory for the individual traumas of the series' protagonists.

This substitution of collective crisis through extreme individuation is systemic to liberal climate propaganda, even foundational, and is possibly most extremely visible in the series *The Commons* (2019), in which viewers follow the lives of predominantly white characters living in the city-state of Sydney in a near future climate-plagued Australia. In this climate fiction that is

already reality in many parts of the world, the countryside has essentially been abandoned and its population stripped of citizenship. Millions of stateless are on the run, facing devastating droughts and the raging Chagas disease that has migrated from its equatorial habitat due to rising temperatures, as they seek safe harbor in harsh border patrol "resettlement centers" in the hopes of getting access to the cities. The lives of the inhabitants of the city-states, on the other hand, are serviced by high-tech interfaces, including rain acidity predictions, biotech wellness gardens to treat the anxieties of the urban elites, and a fleet of drones that police the street for undesirables. In this privileged environment, neuropsychologist Eadie Baulay, who struggles with fertility issues and has exhausted the state-regulated in vitro fertilization services, is now seeking black market options instead. The millions of futures on the run—including those of Aboriginal peoples, the true stewards of the land—are nothing but a backdrop in the overall runtime dedicated to the reproductive concerns of the white consumer class that suffers the least. Here, climate collapse becomes an analogy for individual infertility, rather than a threat to the regenerative capabilities of ecosystems for all.

Climate Savior Complex

The liberal climate propaganda examples *The Affair* and *The Commons* make painfully clear that when liberal narrative suggests that "we"—a generic humanity—are the cause of ecosystem collapse, this does not mean that "all lives matter" equally in the subsequent catastrophe, despite the fanaticism with which those challenged in their privilege by the Black Lives Matter movement like to assert. Inherent to liberalism's centering of the individual is the performance of an enlightened benevolence—a rhetorical acknowledgment of concern regarding the dying refugee or the burning forest. And, all too often, this staging of concern is itself heavily sponsored by the fossil fuel industry, possibly most visible in the sphere of contemporary art, where exhibitions that thematize notions like degrowth

and sustainability are relentlessly funded by oil and gas giants. Think, for example, of Tate Modern in London, which only divested from twenty-six years of fossil fuel sponsorship by BP after relentless performative interventions by the art collective Liberate Tate.[22] Liberal empathy is toxic, and exists by grace of the fact that its consumer class experiences the least of the consequences of the catastrophe. Liberals lose nothing from feigning fossil fuel–sponsored concern about the environment, but they win everything in the form of enlightened consciousness to offset their own climate loneliness and guilt.

Such poisonous empathy also introduces the highly marketable realm of the (white) climate savior complex, of which Al Gore's infamous lecture-documentary *An Inconvenient Truth* (2006), followed by *An Inconvenient Sequel: Truth to Power* (2017), has proven a particularly successful model, replicated by other celebrities turned liberal climate activists, such as Leonardo DiCaprio and his documentaries *The 11th Hour* (2007), *Before the Flood* (2016), and *Ice on Fire* (2019). In the films, we witness Gore and DiCaprio hovering by helicopter or driving by Humvee across devastated landscapes, showcasing their celebrity access to every imaginable form of transportation, leaving no square centimeter of the globe unchecked. But this is their luxury burden, their power to see, what we, average consumers, lack access to. There is a strange sacrificial component to their films, as they take on the weight of a devastating knowledge about a collapsing world, while taking some time off from film shoots and lobbying work. And the message of the celebrity messiah to the precarious climate lonely does not deviate from the liberal climate propaganda norm: consume green, vote consciously, but remain lonely still. The main revenue of their "activism" is that the white male savior lives another day.[23]

The climate savior complex relies on climate-splaining. Powerful celebrity men, who inherited the benefits of colonial Empire while living in the safeguarded mansions of the Global North, once again take central stage to save the world from themselves. Here, we witness the same climate-splaining that toxifies the air of UN Climate and Davos summits, in which the

Liberate Tate stage a performance on April 20, 2011, in Tate Britain on the anniversary of the Deepwater Horizon explosion that killed eleven workers and released 4.9 million barrels of oil into the Gulf of Mexico. Photo: Amy Scaife. Courtesy of Amy Scaife.

now eco-enlightened North explains to the Global South the need to stop industrial expansion, and shares the gospel of blessed renewables and carbon offsets. While the North extracted resources from the South over the course of centuries, now the so-called developing countries will be climate-splained on how to underdevelop their resource capital before it is too late. In the name of liberal benevolence, they offer subsidies and World Bank microcredits—indebtment—but without talk of structural reparations or planetary wealth redistribution, which they owe as a result of colonial robbery and enslavement.[24] This happens while they simultaneously demand that those countries in the Global South keep their cobalt and lithium mines open and child laborers available to mine the minerals needed for the North's next generation of "sustainable" tech.[25]

2 Libertarian Climate Propaganda: Extinction as Currency

Seeds of Empire

On May 5, 1725, Leendert Hasenbosch, a Dutch soldier and book-keeper for the East Indian Company, becomes the first known inhabitant of the volcanic Ascension Island, located in the Atlantic Ocean approximately 1,000 miles (1,600 kilometers) from the west coast of Africa.[1] Hasenbosch is exiled from his ship after he's been found engaging in sexual intercourse with a lower ranked sailor, and is left on Ascension's beach with a tent, a cask of water, a musket without bullets, a bale of rice, two buckets, and an old frying pan.

Hasenbosch keeps a diary of his days as the only human inhabitant of the volcanic island, a document later found by English sailors, the final entry dated October 25 of the same year. From his writings, we know he wanders the island looking for water and hunting birds and turtles, all while searching for a possible other ship to escape. As his water reserves become undrinkable, he is tormented at night by hallucinations

The Target Tracking Radar Station, known as the Golf Ball, on Cat Hill, Ascension Island, currently operated by the joint NSA-GCHQ Composite Signals Organisation facility. Photo: Jerrye and Roy Klotz. CC BY-SA 3.0.

of screaming shadowy beings raging outside his tent. The last entries of his diaries describe him parched, sucking blood directly from the neck of a bird he managed to catch, and draining the bladder from a turtle to drink its urine. Hasenbosch's body was never found.[2]

But Empire was not done with Ascension: Hasenbosch, the colonist "sodomist" outcast, would not be its last inhabitant. Charles Darwin, having left the English shores on the HMS *Beagle* in 1820, considered the desolate volcanic island, which had by now been claimed by the British Crown, as the ideal site to experiment with what we could consider one of the first large geoengineering endeavors in history. His close friend Joseph Dalton Hooker would be tasked with the operation, working with the British Navy and the Royal Botanic Gardens in London to construct an alternative biosphere by planting trees on the island to terraform a solid base for a broader ecosystem to be translocated. Plants and seeds from Europe, Africa, and South America were brought in, and by the 1870s eucalyptus, pine, bamboo, and palm trees had taken root.[3]

After being fertilized with looted plants and goods from colonial missions, the period leading to the Second World War saw Ascension become heavily militarized, the island turned into a site for radio transmission and a staging point for aircraft. Today, Ascension has no citizens, and the only point of entry is by military plane or boat. Not only the US and British armies have set up their facilities, but also the National Security Agency (NSA) and Government Communications Headquarters (GCHQ), as well as NASA and the European Space Agency, techno-formed the island by installing post-detection telemetry systems, mobile climate research facilities, ground antennas, and deep space surveillance systems on the island's geoengineered landscape.

Ascension Island became a mirror of Empire, from the first exiled crew member to its engineered ecosystem and military apparatus. But we can easily recognize another seed that was planted in its volcanic rock: the seed of libertarian propagation. For today, Ascension island embodies a renewed colonial dream

proffered by tech entrepreneurs like Peter Thiel, Jeff Bezos, and Elon Musk to declare large parts of Earth and outer space as terra nullius (nobody's land) and to geo-engineer new habitats in the form of floating cities or colonies on the Moon and Mars. They are imagined as sites of massive technological experimentation with no democratic oversight, where rights-bearing citizens have been replaced with disposable workforces. Hasenbosch's fate—first recruited and then exiled by Empire—equally awaits the many precarious workforces of the future that will be sacrificed to terraform other planets for the space-faring trillionaire class to thrive on.

In the twenty-first century, as the power of the nation-state wanes, various new Ascension islands emerge. They are no longer the product of former kingdoms and states of old, but firmly under control of the libertarian trillionaire class and its new techno-feudalist visions of Empire.[4]

The Drowned, Exiled World

As the colonial empires of old are replaced with the libertarian empires of new, a floating ocean city appears, made up of sleek white interconnected hexagon-shaped modules, covered with luxury villas emerging from green patches, and yachts docked along the edges. The glossy structure evokes Norman Foster's design for the circular Apple Park (headquarters of Apple Inc. in Cupertino, California), but is reimagined as a buoyant, floating architecture, heavily reflecting the brutal radiation the sun casts upon a drowned world.[5] This is the Seasteading Institute, the libertarian dream of Peter Thiel, cofounder of PayPal.

For Thiel, the impending flooded world of climate collapse is not a catastrophe, but raw material for new geo-markets to emerge.[6] He almost had the French Polynesian government on board as a permanent autonomous Seasteading settlement began development off the coast of the South Pacific islands. As rising sea levels are a threat to the very existence of the islands and their government, a transition to floating islands—even if

Artist's concept of Artisanopolis, sustainable domes and power grids. The Seasteading Institute and Gabriel Scheare Luke & Lourdes Crowley, and Patrick White. CC BY-NC-SA 4.0.

that would mean transferring partial sovereignty to unelected tech entrepreneurs like Thiel—was a tempting scenario for the future survival of the "French overseas territory." The Seasteading Institute was to be exempt from external governance or taxation, as only selective local and environmental law would apply. But Tahiti locals began protesting what they rightfully perceived as "tech colonialism," and the temporary agreement was discontinued by the French Polynesian government as a result.[7]

Thiel's floating island phantasm is low on imagination, as it essentially follows the textbook libertarian scripture known as *Atlas Shrugged* (1957), a novel by Ayn Rand. The book describes a near future scenario in which the capitalist entrepreneurial class considers itself overtaxed and hyper-regulated by states, undermining their productivity and creativity. Guided by a mysterious figure know as John Galt, the capitalist moguls are persuaded to go on "strike" against what Galt considers "state looters," by abandoning their companies to build a new "rationalist" capitalist utopia elsewhere, premised on individual sovereignty and the abolition of the (welfare) state.[8] Today, Thiel is far from the only one dreaming of navigating a drowned world, turning the sixth mass extinction into a currency pool for the elite one-tenth of the global 1 percent.

Or maybe we should say half of one tenth of 1 percent. For if half are obsessed with profiting from a drowning Earth, the other half are epitomized by Elon Musk, cofounder of the Space Exploration Technologies Corporation, or "SpaceX," as well as Amazon founder Jeff Bezos, who created his own space faring company, Blue Origin: their eyes are set on what is to become the terraformed "back-up planet" Mars.[9] In Musk's words: "We stay on Earth forever and then there will be an inevitable extinction event," or we can "become a spacefaring civilization, and a multi-planetary species."[10] To be geoengineered with cheap labor, Mars is imagined as the new home of Silicon Valley elites—the world's designated survivors—who have declared themselves a new generation of "colonizers" and "pioneers." For the libertarians, Mars is a "dead planet," an untapped resource, a fossil

waiting to become fuel, just as their colonial ancestors declared vast parts of Earth terra nullius of their own.[11]

The first two seasons of the television series *Mars* (2016–present), produced by National Geographic, can be read as a docu-fiction infomercial for Musk's company. Its documentary component shows SpaceX's present-day tests of reusable rockets, intended for travel back and forth to Mars, while its Hollywood science fiction–styled segments visualize Musk's year-by-year plan to terraform the planet into a sustainable biosphere for human inhabitation. SpaceX imagines that humanity's transition from a planetary to an interplanetary species will transpire through extractivist pursuits. The planned Martian settlement visualized in the series includes spaces to sleep, laboratories for studies and experiments, agricultural areas to grow plants, and, in time, a bar, all of which were reproduced for the launch of the television series for the public to experience on a 1:1 scale. What remains to the space proletarians is the sci-fi-inspired sleek, white cornerless design of their claustrophobic living quarters to remind them that this is, indeed, the future, while the corporate components of the mission that finance its scientific pursuits mine the planet's resources: first water and, in the long term, also nickel, copper, iron, titanium, and platinum.[12] The plan includes no physical political infrastructures to speak of, or any meaningful discourse on future forms of governance or political organization; there is no space for common decision-making or even a parliament.

In fact, in the agreement that satellite users of the SpaceX subsidiary Starlink have to sign, the tenth clause reads: "For Services provided on Mars, or in transit to Mars via Starship or other spacecraft, the parties recognize Mars as a free planet and that no Earth-based government has authority or sovereignty over Martian activities."[13] Referring to Mars as a "free" planet in this context does not mean that either Mars or its future inhabitants will have political agency themselves; rather, it speaks to the proprietary rights of SpaceX to extract and geoengineer the planet without any governmental or democratic interference.

General view of the first ever Mars show home unveiled by National Geographic to coincide with the premiere of docu-drama *Mars* (2016), based on the research of Stephen Petranek (author of *How We'll Live on Mars* and consultant on *Mars*) and astronomers at the Royal Observatory. PA Images.

In their terraformed biospheres, the libertarians rule supreme. Extinction is their chance for market expansion, their opportunity to become the world, no matter if it's a drowned or exiled world. As even then, they can monopolize its ruins.

Designing Extinction

For such projects to move from science fiction and the egos of the ultra-rich to reality, propaganda serves a key role, and an important tool of libertarian climate propaganda is precisely the rendering of this future, making the future visible. The glossy allure of Thiel's and Musk's sci-fi inhabitations of drowned and exiled worlds lies in a form of visualization that hides the disasters that enable them to come into being in the first place. Images of the Seasteading Institute's floating islands do not evoke the millions of human deaths resulting from a

climate shaped by perpetual tsunamis and raging super-fires. Their polished computer models instead function like Apple products, which separate the ruthless reality of the Foxconn factory gulags from the user's product experience. And so, Thiel's and Musk's future renderings show not millions of climate refugees and water wars, but lushly forested floating cities and a greenified Mars where high-tech infrastructures have reduced labor, and the problem of democratic governance is resolved through fully engineered luxury environments responsive to their inhabitants' every need. The fact that the first Seasteading Institute aimed to host no more than 200 inhabitants, and thus only provides survival residence for the super elite, is of secondary importance to the libertarian allure that "we" could be those chosen ones.

Similar to the copycat Randian utopias of Thiel and Musk, libertarian propagandists uncreatively appropriate mainstream science fiction and its CGI arsenal as its main image-rendering machinery. When it comes to the impact of science fiction in shaping our reality and futures, blockbuster Hollywood cinema instantly comes to mind. The body scan in *Running Man* (1987) is now a structural part of airport life. The electric vehicles in *Gattaca* (1997) are now a Tesla monopoly. Tom Cruise's use of touch screens in *Minority Report* (2002) prefigured the iPhone and iPad. But this is not an "organic" consequence of major science fiction culture, but rather planned, given that tech-industry and industrial designers product-place technology that they are developing in mainstream science fiction.[14] Thus, viewers and consumers get trained to recognize products that are yet to be launched on the market. Once they are, they become instantly familiar, as the collective imaginary has already been conditioned for their use.

Libertarian climate propaganda has fully appropriated this technique of product-placing the future, for example, in the sci-fi designs of so-called smart city architectures commissioned by Eric Schmidt, former CEO of Google, owned by parent company Alphabet. During the COVID-19 pandemic, Schmidt immediately recognized the disaster as an opportunity to pitch

his smart city models: high-tech responsive urban environments that turn cities into data architectures.[15] Smart cities are extractive interfaces that harvest information on its citizens' movements and behaviors, as well as their health, which in the context of the pandemic, responded to an immediate public urgency that could tip city governance in Schmidt's favor. Place his smart city architecture models next to those of science fiction film designer Syd Mead—who pitched his industrial product designs for decades in films such as *Blade Runner* (1982) and *Tomorrowland* (2015)—and it's hard not to see the repetition of the same product-placing strategy.[16]

The field of so-called creative industries is an essential component of libertarian climate propaganda, as smart city infrastructures and Mars colonies are pitched not only as consumer friendly, high-tech, and sustainable solutions for human survival, but also as promises of a certain aesthetic futurism. Design entrepreneurs like Daan Roosegaarde, who created a glow-in-the-dark "smart highway" of his own, are exemplary for the emerging design forms of our extinction and the aesthetic experience of survival for the Earth's elites he offers to clients ranging from ING bank, BMW, and NASA.[17] Roosegaarde's work *Smog Free Tower* (2015), for example, a sleek seventeen-meter-high aluminum layered sculpture, provides the illusion of a quick technofix to pull carbon from the air, out of which the *Smog Free Ring* (2017) is made, in which instead of a diamond, there is a condensed black cube of smog particles. Another of his projects, the *Space Waste Lab* (2018), projects green light beams into space, to map the location of an estimated 8 million kilograms of space debris, with the eventual aim of capturing and recycling the polluted trash into new (sellable) products.[18] In all cases, a glossy, sometimes spectacular design product or event is aimed to comfort and encourage us to hand the keys over what remains of our futures to the extinction designer, hoping that the world they promise actually has a place for us.

Following the logics of the libertarian propagandist, Roosegaarde is not concerned with the systems and causes that create pollution but is rather interested in turning pollution into

Daan Roosegaarde, *Smog Free Ring* (2017), collected smog particles, transparent cube, stainless steel, and other media. Part of the Smog Free Project. Courtesy of Studio Daan Roosegaarde. CC BY-NC 4.0.

design object merchandise. For him, extinction is not a threat to living worlds, but a design opportunity first and foremost. It is easy to imagine how smog-free towers would litter Thiel's Seasteading Institute, or how the Space Waste Lab is employed in Musk's or Bezos's space colonization programs. Extinction is their shared market. What matters is not what is left for the many, but what services and jewelry are available for the designated trillionaire survivors on their floating cities and Mars settlements. Like the American Dream, the Extinction Dream exists only for the elite's elite.

An extraterrestrial monument to the elite's elite is Jeff Koons's *Moon Phases* (2022), a series of 125 moon sculptures, each one inch (2,5 centimeter) in diameter, representing the different phases as seen from earth of our only natural satellite. The objects are displayed in a transparent, compartmentalized cube that will be stationed on the surface permanently through a Nova-C Lunar Lander transported by a SpaceX Falcon 9 rocket as part of a mission carrying NASA payloads. Each of the sculptures will be named after someone admired by the artist, with

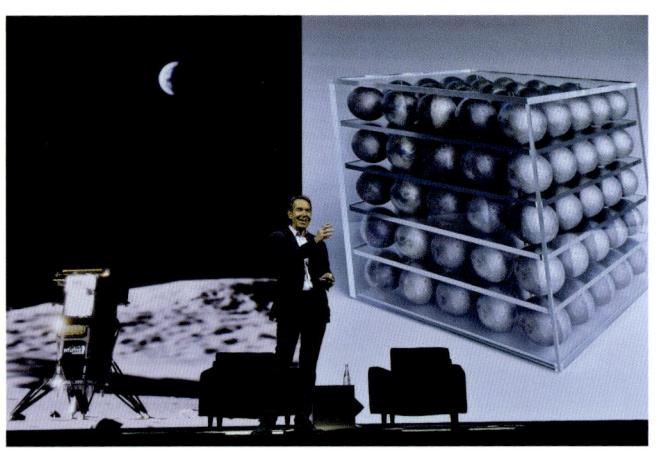

Artist Jeff Koons talks about sending the first authorized artwork to be placed on the surface of the moon at Adobe MAX on October 19, 2022, in Los Angeles. Jordan Strauss/AP Images for Adobe.

possible names including "Marcel Duchamp, Elvis Presley, Marilyn Monroe, Leonardo da Vinci, Sacagawea, Sojourner Truth, the ancient Greek sculptor Praxiteles and Ileana Sonnabend, a dealer who once represented the artist."[19] Whereas the miniature moon sculptures that will be transported to the moon's surface are packed in an efficient cubical plexiglass storage device, 125 corresponding larger moon sculptures stay on Earth with an added precious material—ruby, emerald, sapphire, or diamond—that indicates the location of the box of moon sculptures on the lunar surface. A corresponding 135 nonfungible tokens, or NFTS—the libertarian's artistic digital object of obsession, as we will be discussing in more detail later on this chapter—will be released simultaneously.

Koons claims his work is aspirational, that the smooth surfaces of his ultra-expensive commodities reflect an image of what people could become, what they could achieve, what they could own.[20] But the truth is that his *Moon Phases* reflect only the faces of the elite's elite. The Earth majority left out of the libertarian spacefaring escape who will burn, drown, and suffocate don't reflect in Koons's work. *Moon Phases* is the first extraterrestrial monument for the trillionaire class to come, as they leave for a terraformed Moon and Mars to escape their own catastrophes. A monument made by a millionaire artist more concerned with colonizing the Milky Way by artistic means than to care and repair for the world through which he obtained his wealth in the first place, *Moon Phases* is a major work of extinction design, and a betrayal to the many, to the living—to Earth.

This field of "extinction design" is countered by artists such as Femke Herregraven. Her *Volatility Storms* (2014), for example, is an online database in the form of an "investment portfolio" full of ultra-professional-looking charts and figures, which lays out the emergence of libertarian extinction markets. The melting Arctic, Herregraven explains, allows for new submarine cables to be laid on its sea floor, quickening the data connection between the Tokyo and London financial markets, which currently depend on cables that run via the Pacific and Middle East: "Less ice means more money, in less time."[21] Melting ice also opens

up new mining resources of oil and gas fields in the Arctic seas, and newly thawed tundras will allow for massive agricultural development, as well as access to reserves of zinc, iron, gold, and nickel. In the portfolio, viewers also encounter "catastrophe bonds" that turn "floods, volcanic eruptions, hurricanes, earthquakes and tsunamis into financial products."[22] Essentially, a buyer invests in catastrophe insurance, and loses money in the case of climate disaster; or one can counter-invest in the possibility that the disaster *will* happen within a predetermined number of years. Another asset in the portfolio is the "species swap derivative," which explains the profitability in speeding up species extinction for those who have stocked up on frozen Atlantic bluefin tuna and other threatened species, turning vaults of frozen animals into stocks of potentially limitless value. Last, similar to the catastrophe bond, the portfolio offers "species swap derivatives" to invest in a given species' chance of survival or extinction: "Species as renewable or nonrenewable resources, betting on extinction or survival works either way."[23]

Underlying libertarian climate propaganda, as Herregraven's research makes painfully clear, can thus be called an "extinction loop." It demonstrates how libertarians embrace extractive industries that accelerate ecosystem collapse because their truest resource is climate collapse itself, in that it allows them to build their geoengineered, terraformed, private biospheres through techno-feudalist rule, decorated with extinction design: from carbon-capturing towers to moon monuments and the frozen trophies of the Earth's extinct. Their "solutions," whether carbon-capture or floating infrastructures, are not really solutions, but rather the desirable consequences of the accelerationist planetary disasters they engineered themselves.[24] In short, extinction is their currency.

The Last Currency

The emergence of cryptocurrency is a key libertarian building block to turn extinction designs into reality. Major

cryptocurrencies like Bitcoin and Ethereum have been joined by thousands of cryptocurrencies, which at a peak in 2021 totaled an estimated value of more than 3 trillion dollars before facing a major downfall the following year with the collapse of the FTX international exchange for crypto assets. Cryptocurrency runs on blockchain technology—designed by the mysterious Satoshi Nakamoto, who might be either an individual or a group—and is a stateless virtual currency that can operate without control by governments or banks, though established financial institutions are doing their best to capitalize on the market.[25] It's the libertarian dream, following their adulation of (neo)liberal economist Friedrich von Hayek, whose book *The Denationalization of Money* (1976) relished the possibility of a future in which regulatory democracy would be removed entirely from the production, distribution, and management of capital.

It is not surprising that libertarian propagandists are leading supporters of the cryptocurrency market. Elon Musk's companies held $1.5 billion in Bitcoin before becoming a core supporter of the "Dogecoin," a cryptocurrency that started as a mockery of Bitcoin using the famous "Doge" meme consisting of a Shiba Inu dog with its eyes wide open, onto which users would place the dog's supposed misspelled internal monologue. After Musk declared himself the "Dogefather," announcing that Tesla products could now be purchased with Dogecoin, the value of the coin rose by 50 percent, before plummeting in the subsequent crisis. For libertarians, cryptocurrency and the ideal of decentralized finance, or "DeFi," represents a path away from government regulation and power to destabilize existing financial institutions by creating parallel economies in support of their own world-making efforts. No surprise that its core supporters, like Musk, remain unwilling to divest from cryptocurrency.

Cryptocurrencies consist of digital tokens that can be used as a means of transaction by being sent electronically from one user to another, wherever digital connections can be established. The blockchain is essentially a record of transactions, meaning that each block of the blockchain consists of a unique

data transaction fingerprint linked with all other blocks, allowing users to keep an overview of all transactions taking place across the network. Having no centralized authority, trust in the blockchain is in the encryption of its chain. Rather than trusting a government or bank, one trusts complex math. Cryptocurrency's value is created by a process called "mining." Bitcoin and Ethereum users, for example, can mine their own coins that are inscribed into the blockchain, by letting their computers solve complex mathematical problems—something that requires vast amounts of energy that emit huge amounts of pollution. The value of Bitcoin or Ethereum thus equals the amount of energy and computing power needed to create it, combined with the willingness of people to embrace the currency as their own as well as investors feeling incentivized to turn their assets into crypto.[26] Like anything digital, these currencies are in fact produced through material means.

Taxing cryptocurrencies has proven notoriously difficult, and some countries, like Bermuda, Malta, Gibraltar, and Liechtenstein, have created havens for crypto holders and companies. And while blockchain's decentralized technology holds some potentially transformative promise when it comes to rethinking voting processes and self-organized micro-energy grid management, it currently favors those with the means to purchase digital currency, or to perform the mining itself: the more computational power one can mount, the more cryptocurrency one can mine. That means that rather than a central bank, "central miners" can disproportionately impact the number of coins circulating and the value they hold on the (crypto)market. No surprise, then, that Thiel's Seasteading Institute announced its short-lived "Crypto Cruise Ship" in 2020, named the MS *Satoshi*, in honor of the blockchain founder.

Thinking about the rise of cryptocurrency as the "last currency" is more than metaphor considering its devastating environmental footprint. At its current rate, environmental damages through mining are calculated to potentially produce enough emissions to warm the planet above the apocalyptic two degrees Celsius in a mere twenty-two years.[27] Parts of crypto mining have

moved into the sphere of renewables and carbon offset schemes, particularly in the art world, where various figures and institutions have begun to partake in generating cryptovalue in the form of so-called nonfungible tokens (NFTs), unique digital ledgers stored on the blockchain that can consist of a digital image or video. Digital artist Mike Winkelmann, or "BEEPLE," saw his digital NFT artwork *Everydays: The First 5000 Days* (2021) sell for $67 million at Christie's auction house. The work consists of a collage of the daily digital paintings the artist published on his website, which read like the dark underbelly of X (formerly Twitter) misogyny, homophobia, and racism. Winkelmann is obsessed with fat shaming, the supposed sexual perversions of political and religious leaders, and the portrayal of aggressive racialized sexual stereotypes.[28] Staggering sums are paid for energy-killing crypto paraphernalia that glorify an incel-induced culture of racial and gender violence. As such, extinction as currency embodies a clear banality of evil: the banality of extinction.[29]

The ultimate cynicism might be on display when the United Nations presented an NFT art show highlighting the issue of climate change titled "DigitalArt4 Climate" at the COP26 Climate Change Conference in Scotland in 2021—embracing the

COP26 collection by DigitalArt4Climate (2021). Image: Digital gallery of the DigitalArt4Climate COP26 nonfungible token (NFT) collection. Courtesy of DigitalArt4Climate and Artgence.

very technology that shamelessly accelerates the environmental crisis the summit is ostensibly mean to combat.[30] For even if NFTs could be produced through renewable energy, this does not undo the fact that "sustainable" energy infrastructures are themselves reliant on vast mineral extraction and industrial production.[31] As long as the myths of endless progress and consumer culture are not dismantled, increasingly energy-hungry digital economies will consume renewable resources away from primary common needs.

Such extreme energy extraction investment opportunities are already widely available, the booming field of so-called artificial intelligence first and foremost. It is of course deeply cynical to be willing to ascribe "intelligence" to algorithms, but not to, say, pigs or flowers. The choice to do so is because AI is considered a replication of "our" intelligence. The ultimate expression of human supremacy over nature is our supposed capability to extrapolate our own intelligence into servitude, to extract our thought-world as capital, the way protagonists in Brandon Cronenberg's film *Infinity Pool* (2023) reproduce themselves for executions, never entirely knowing whether it is themselves or their copies who are being killed. But while the costs in Cronenberg's film are murderous, the cost of AI markets is omnicidal, as they rely on stupendous amounts of energy for computing power, which are projected to be greater than the entire human workforce by 2025, and its global energy consumption to reach 3.5 percent of the world's total by 2030.[32] While cryptocurrency may be the last currency, artificial intelligence promises to be the last intelligence.

Considering the libertarian climate propaganda extinction loop (wherein a false solution to a crisis becomes justification for deepening the crisis itself), there is no contradiction in ruining living worlds by building a predatory energy economy, as this is the point: libertarian propagation accelerates ungovernability to engineer its own worlds in the old system's place.

Violent Optimism

The violent optimism with which extinction designers, engineers, and programmers facilitate libertarian climate propaganda does not mean they will be part of the techno-feudalist worlds they are helping to bring into being. The documentary film *Spaceship Earth* (2020) directed by Matt Wolf is a cautionary tale in that regard. It follows John Polk Allen, a system ecologist and founder of the Theater of All Possibilities, who from the 1960s onward organized commune-like groups that developed experimental theater, utopian environments, and exploratory travel projects. Allen and his "collective" pioneered the merger of communalist hippy culture and capitalist entrepreneurism, building their own investment portfolio in the process as they managed to find increasingly large funders for their projects—such as businessman and billionaire philanthropist Ed Bass—to the point where his dream to create the largest ever human-made, closed ecosystem on Earth became reality: Biosphere 2, comprising 1.27 hectares of land, inaugurated in 1984 in Oracle, Arizona.

The aim of Biosphere 2 was to replicate the Earth's ecology, from deserts to rain forests, across different intersecting spheres situated within an enormous pyramid-like glass dome structure. Allen's team became the first to occupy the facility permanently, with the aim of testing the possibility of building self-sufficient ecosystems as part of interplanetary space colonization missions. While the biosphere project was already deeply colonial in nature, to add to this, its plants and animals were abducted by the collective from across the world, manifesting as a giant botanical garden placed on stolen land.[33] The biosphere did not hold, though, as certain parts of its internal ecosystem took over others, and when the oxygen ran out, the Biospherians were forced to leave the facility. Under the directorship of the new CEO Steve Bannon—who would later infamously become a prominent alt-right filmmaker and Donald Trump's campaign manager—Allen and his team were exiled from the by then financially deprived project.[34]

Biospherians (left to right) Bernd Zabel, Taber MacMullen, Mark Van Thillo, Jane Poynter, Linda Leigh, Roy Walford, Abigail Alling, and Sally Silverstone posing inside Biosphere 2 in a 1990 photoshoot. Courtesy of Institute of Ecotechnics.

In other words, designers of the libertarian futures like Allen are not certain to be allowed to take part in those futures when they are ruled by unaccountable tech entrepreneurs and trillionaires. The libertarian future literally relies on our demise: just like Leendert Hasenbosch's bones reside somewhere under the geoengineered biosphere of Ascension Island, the future bones of the many precarious earth workers sent to Mars will be buried under a terraformed world in which they will have no stakes at all. Bezos's 2021 press conference, after having just returned from his eleven-minute trip to the outer atmosphere in a penis-shaped rocket made by his Blue Origin company, is telling in this regard. Dressed in a blue space uniform topped with a cowboy hat to emphasize his new status as a space pioneer, he stated to the assembled press: "I want to thank every Amazon employee and every Amazon customer because you guys paid for all of this."[35] And work for it they did: uncontracted, banned from unionizing, without social security, forced to pee in bottles and wear diapers to meet production targets in windowless warehouses—all so that their CEO could leave Earth without them.

3 *Conspiracist Climate Propaganda:
The Extinction Hoax*

The Flat Earth Anti-Globe

An artificial sun rises over a flat surface placed underneath a plexiglass dome. Under the rotating light viewers witness the familiar geographical contours of the world's continents slowly appearing and returning into the darkness of night. But the planet's usual curve has disappeared in this model: it is only one out of many anti-globes lined up in the workshop of flat Earth activist Chris Pontius.[1]

Thousands of conspiracists who have joined various competing "flat Earth societies" are convinced that NASA, in collusion with various governments and other globalist actors, propagates deepfake photographs and video materials to engineer the false majoritarian conception that the world is round. In response, flat Earthers have developed their own vast theoretical frameworks and "scientific" experiments to prove the contrary. For one example, the flat Earthers' "Zetetic method" stems from earlier flat Earth societies of the nineteenth century,

emphasizing the importance of individualist sensory observation.[2] If the world *looks* flat, it means it must *be* flat. Or, in the words of American rapper and flat-Earther B.O.B, speaking to his social media followers, whom he calls "cadets": "No matter how high in elevation you are ... the horizon is always eye level ... I didn't wanna believe it either."[3]

A dominant narrative following from applying the Zetetic method among flat Earth theorists and researchers is that the Earth is in actuality a disk, with the Arctic Circle at its center. The sun and moon are spheres that are thirty-one miles (fifty kilometers) wide, which hover in circular patterns above our Earth disk, projecting what resemble spotlights on the surface. Antarctica is the "rim" of the disk in the form of a massive wall of ice, which is guarded by NASA employees. Together with other government agencies and globalist networks with whom NASA operates the round-Earth hoax, they benefit by receiving funding for space programs that in reality do not take place, providing them means and resources to become a parallel government in their own right.[4] Chris Pontius has taken to the task of building, with great craftmanship and dedication, the reality propagated by the Flat Earth Society; his anti-globes are massively popular among the citizens of this parallel, disk-shaped world.

The flat-Earth anti-globe is an appropriate model with which to analyze conspiracist climate propaganda. In this case, it takes the form of an entirely new ecosystem with its own laws of physics, considering that the Flat Earth Society believes gravity is an illusion and that a mystical "dark matter" is the primary energy source that pulls the Earth disk "upward." This strange doubling of a reality into an alt-reality—from the globe to the disk—is manifested across different conspiracy networks and their corresponding industries.[5] For example, the Heartland Institute—a key creator of aggressive fossil fuel propaganda—has been a leading force in financing scientists willing to downplay or deny climate catastrophe, and also founded its own "NIPCC"—an organizational twin of the existing Intergovernmental Panel on Climate Change, the "IPCC."[6] And even bodies can be doubled in the anti-globe of the alt-world. Think of Greta

A 2008 azimuthal equidistant projection of the entire spherical Earth by Flat Earth Society member Trekky0623. The white around the outside of the globe is thought to be an "ice wall," preventing people from falling off the surface of the Earth.

Thunberg's alt-body double, Naomi Seibt, the climate change–denying "Anti-Greta" who has gained heroic status in conspiracy climate propaganda.

Climate Lockdown

Conspiracist climate propaganda is a huge industry with world-making agency. The antivaxxer movement, for example, that for decades has claimed vaccines cause autism, has gained enormous traction during the coronavirus pandemic and is now estimated to have become a global multimillion-dollar industry that produces its own films and videos, activist manuals, and "natural" medicine and treatment plans. Big Tech, such as Meta, X, and YouTube, are essential for the dissemination of their conspiracist propaganda, but, through advertisement revenue, also benefit enormously from the traction they generate.[7]

In the early months of the COVID-19 pandemic in the Global North, Mikki Willis's misinformation bomb *Plandemic: The Hidden Agenda behind Covid-19* (2020) went viral. This documentary-styled conspiracy video featured former research scientist Judy Mikovits, who simultaneously launched her book *Plague of Corruption: Restoring Faith in the Promise of Science* (2020), which soon sold out on Amazon. In the video, Mikovits is introduced as a scientist who "revolutionized HIV research" and has bravely stood up against the profit motives of the pharmaceutical industry and government agencies, with arrest and an imposed gag order as a result.[8] In actuality, Mikovits was fired for publishing unfounded research and was placed under temporary arrest for allegedly removing notes from the laboratory after her dismissal.

Her battle with the medical establishment, Mikovits argues, is one against "absolute propaganda" embodied by the figure of Anthony Fauci, the former Chief Medical Advisor to the US President.[9] The coronavirus, Mikovits claims, was manipulated, somewhere between "the North Carolina Laboratories, Fort Detrick US Army Research Institute of Infectious Disease and the Wuhan Laboratory."[10] Fauci had worked at the Wuhan lab

before; was he implicated in the virus's development and, possibly, its spread? And how did that relate to his active rejection of nonpatented medicine such as hydroxychloroquine—a drug favored by Trump—or natural treatments, such as the "healing microbes in sand and seawater"?[11] Is this not a scheme to ensure maximum distribution of patented vaccines sidestepping other treatments, and what are Fauci's stake in the patents, and to what personal profits? As tends to be the case with many conspiracist narratives, *Plandemic* does not propose facts, but claims to ask "critical questions," which is an effective way of sowing doubt about mainstream narratives without having to provide substantiated proof. Exploiting legitimate and necessary skepticism regarding the interests of the medical establishment and Big Pharma, conspiracist climate propaganda creates an alt-reality—and alt-industry—of its own.

Willis's follow-up film, *Plandemic: Indoctrination* (2020), deepens the rabbit hole opened by Mikovits and expands its panel of "experts" in the form of internal medicine specialist Meryl Nass and virologist and Nobel laureate Luc Montagnier to double down on the supposed human-engineered nature of the virus, the role of Big Tech (by censoring critical information) and Big Pharma (by profiting from patents) in orchestrating the global health crisis, and the dangers of vaccinations altering "natural" human biology. The latter feeds into the idea of the "Great Reset," originally used as the title of the fiftieth annual meeting of the World Economic Forum in 2020. Ever since, the "Great Reset" became the term with which conspiracists describe how a globalist cabal aims to establish a shadow government—a New World Order—and use vaccines to alter human behavior, regulate reproductive capabilities, and implant microchips to enforce population control.[12]

It is in the Great Reset theory that various conspiracies have come to converge, for example, when Naomi Seibt—the young German self-described anarcho-capitalist and Heartland Institute–funded "anti-Greta Thunberg"—began to retweet QAnon theories. The name is a portmanteau of "Q" and "anonymous," referencing an individual who anonymously posted

on message boards during Trump's first term in power, claiming the status of a high-level government official with "Q-level clearance," a fabricated concept in itself.[13] Q warns of an orchestrated coup against Trump, formed by government agencies as well as globalist players such as Bill Gates and George Soros, who maintain an international child trafficking network used in Satanic rituals that involve the likes of Hillary Clinton and Barack Obama. Seibt instantly gained new followers, converging the theories of a globalist elite trafficking children, the use of vaccines to enforce population control, and the fabrication of a climate hoax to cultivate fear and docility. Here it becomes clear how conspiracies can build on one another and create connections so as to better manufacture a new consent. If one has already been convinced of a conspiracy and encounters a new interrelated one, the new theory is more likely to stick.

As a result, the opposition of conspiracists to COVID-19 lockdowns—which, as the Querdenken movement in Germany showed is not only a right-wing tendency[14]—turned into an opposition against "climate lockdowns": a viral conspiracist prediction circulating under the hashtag #climatelockdown, which argues that just like the pandemic, the climate hoax is weaponized by globalist elites to help the Great Reset come to

Laura Ingraham, host of *The Ingraham Angle*, turns the hashtag #climatelockdown into cable news, May 20, 2021.

fruition. Interconnecting and uniting these various conspiracies and their followers is what Willis calls "The Great Awakening": the counterpoint to the Great Reset central to his latest film chapter *Plandemic 3: The Great Awakening* (2023). Striking in Willis's trilogy is how it narrates not just accumulating COVID-19 conspiracy theories, but also the visual professionalization of the conspiracy market. Having started from scrappy home-edited interviews and YouTube-ripped footage, the latest *Plandemic* chapter appears in a crisp "conventional" documentary style, including polished animations and professional set stages of biolabs. An alt-media for the alt-world, ready to replace the globe as we knew it.

Wellness Industrial Complex

In the summer of 2020, in the midst of the global COVID-19 pandemic, Melissa Rein Lively bursts into anger in a Target supermarket when she comes across a rack of face masks and begins to tear them off, screaming "This shit is over, this shit is over, this shit is over." Quickly termed "QAnon Karen"—Karen being a stereotypical name associated with "rude, middle-aged, and often racist white women"—she went viral.[15] Rein Lively's background, to many, might not immediately seem to naturally click with the QAnon conspiracy. With a history in corporate PR, her lifelong focus was on wellness, natural health, and organic food, and she actively practiced yoga, ayurvedic healing, and meditation—tropes of New Age culture that have been actively incorporated into the practices of many conspiracist and conservative anti-statists. Since the viral incident, she has become a self-described "recovering" member of the QAnon cult, writing books and selling the rights to her life story to act as a cautionary tale, warning of the algorithmic rabbit hole where her pandemic-era forays into natural medicine led her: to embrace the theory of the Great Reset. The cults of wellness and conspiracy that had already been codeveloping over a longer period of time—also known as "conspirituality"—now merged effortlessly.[16]

Wellness is a massive trillion-dollar industry in capitalist countries globally, combining products and services ranging from health to fitness, nutrition, appearance, and "mindfulness."[17] Easily associated with 1990s New Ageism, its top-ranked services, such as Gwyneth Paltrow's lifestyle brand Goop, directly target upper-middle-class consumers. Having been infected with COVID-19 herself, Paltrow self-treated through a "keto and plant-based" diet, drinking bottled mocktails and visiting an "infrared sauna." Mediatizing and marketing her recovery, Paltrow quickly turned this "therapy" into high-priced products for her own company to treat long COVID, such as infrared sauna blankets ($500), HOKA Gore-Tex hiking boots ($220), and a wholeness medallion and gemstone heart necklace ($8,600).[18] Treating climate anxiety is equally marketed by Goop in the form of "earthing," barefoot walking in nature by help of an earthing queen-sized fitted sheet kit, as well as "sound bathing" in desert retreats, smog-resistant skin care products, and the use of "grounding crystals" to realign with the planet's energies. These products are themselves part of relentless extraction: crystals are a billion-dollar industry, and countries with heavy crystal excavation, such as Madagascar, employ tens of thousands of children in its mines. Most consequential of all, these products are central to a market of general distrust in state institutions and their entanglement with private corporations, which gains influence as governments fail to provide structural care and further the violence of austerity in the face of large-scale crises.

Goop's luxury care industry overlaps with aspects of the wellness industrial complex, targeting those who have been termed the "sourdough class": able-bodied, self-employed entrepreneurs for whom the COVID-19 pandemic and other crises are opportunities to realign with their bodies through yoga, gym regimes, fasting diets, experiments in minimalist design and rooftop gardening, bread baking, and spa retreats.[19] In the face of perpetual economic and political instability in the form of pandemics, market crashes, and climate collapse, the able-bodied status of this elite class is the primary capital in

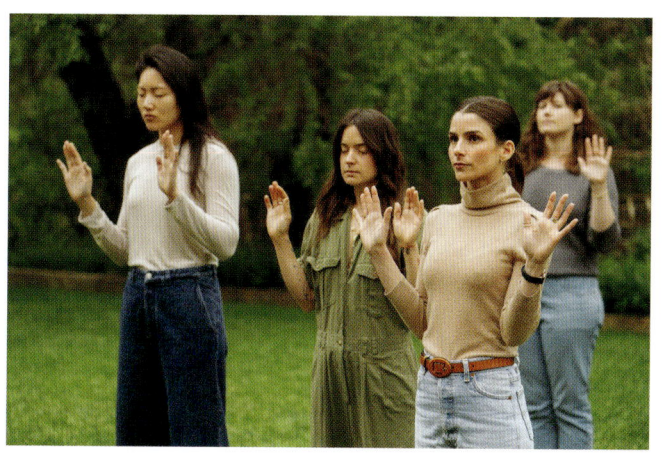

Goop staffers participate in a wellness treatment in Andrew Fried, Dane Lillegard, Shauna Minoprio, and Gwyneth Paltrow (prods.), *The Goop Lab with Gwyneth Paltrow* (2020), season 1, ep. 106. Photo: Adam Rose/© Netflix/courtesy Everett Collection.

need of protection in order to navigate ultracompetitive markets. When life is robbed from communal infrastructures and social security, the wellness industrial complex grows, and so does distrust in public institutions. This is where the rabbit hole emerges between the more liberal segments of the wellness market and its dark undercurrents, as evinced in the story of Rein Lively.

Following this rabbit hole leads us to the world of preppers: people who accumulate natural medicine, enhanced vitamin supplements, foods, weaponry, and—when possible—fenced-off land to prepare for apocalyptic wars to come.[20] The loneliness of the prepper is exploited by the wellness industrial complex: when there is no state to trust, no healthcare to access, no education to afford, no larger community to rely on, no tools to manage crisis collectively, wellness is reduced to individual responsibility for survival.[21] Furthermore, tapping into the freshly concocted individualist mindset, preppers are easily sucked in by patriotic channels that contort old conservative tropes such as "self-reliance" and being "self-made" to fit the new neoliberal mindset. One example is *Natural News*, a website that combines "natural health" treatments and antivaxx and climate hoax messaging from discredited scientists' talking heads with an expanded prepper shopping experience. The *Natural News* store offers seemingly innocent products one could equally expect from Goop, like medicinal mushrooms and non-GMO vitamin C powder, but it also stocks more eerie end-of-the-world merchandise such as the compact Geiger counter nuclear radiation detector dosimeter, a "radiation damage kit," and books with titles ranging from *Survival Nutrition* to *How to Survive the Global Reset*. Here, wellness landmarks such as natural medicine and a justifiably produced but misdirected distrust of corporations and the state begin to merge with a heavily militarized culture of far-right survivalism.

Natural News is thus essentially a slightly more variegated model of Alex Jones's bombastic and ultra-masculine *InfoWars* platform, the rabbit hole's very bottom, offering back-to-nature, armed far-right, antisemitic, New World Order, antivaxx,

prepper misinformation, to the point of claiming that the Sandy Hook elementary school shooting of December 14, 2012, where six adults and twenty children were murdered, was a "false flag" operation involving child actors playing the victims to provide the rationale for the federal government to ban assault rifles. Jones's *InfoWars* shop has pioneered the conspiracy market with "Patriot seeds," water and air filtration products, and Survival Shield supplements to prepare for what Jones has termed "Operation Endgame": an existential battle against a secret, satanic, eugenics-driven world government, led by the likes of Bill Gates and the musician Bono, that aims to eliminate a majority of the global population and to enslave the rest.[22]

Different from the upper-class anxiety catered to by Goop, or the targeting of the sourdough class that promises the preservation of able-bodied status in the free market sphere without a safety net, in the case of the *InfoWars* majority white audience, bodily sovereignty is the only value that remains. Jones's world of far-right insurrection might seem miles apart from Gwyneth Paltrow's upper-class appeal—which does not mean that the *InfoWars* merchandise is necessarily that much cheaper—but their narrative meets in a perceived need to "cleanse" and "purify" bodies from the toxins of the industrial world and pharmaceutical-industrial complex. The lines between them are blurry. In the case of the Goop-like company Moon Juice, for example, founded by wellness influencer Amanda Chantal Bacon, many of the products on sale—ranging from organic fair-trade coffee infused with cordyceps and Reishi mushroom extracts as well as probiotics and colloidal silver drops—are similarly bestsellers in the *InfoWars* store.[23] Each of the different types of prepper communities is premised on the fundamental belief that what remains of the public institutions of old cannot be trusted. This shared distrust turns the body into the central battleground, including those of the upper class (my body is the only thing that matters), the self-employed entrepreneurial class (if I don't care for my body, I can't compete), and the disillusioned reactionary class (they took our country, they won't take my body too).

The path leading from ayurvedic healing to QAnon is far from a given, and there are good reasons why people seek out different approaches to collective health and well-being to resist Big Pharma. And there are many critical struggles for the recognition of (Indigenous) practices and knowledges regarding health, medicine, and healing. What we see in conspiracist climate propaganda, though, is the elimination of some of the most basic common concepts necessary to establish a notion of collectivity. And when distrust is cultivated deeply enough—as we have seen in the rise of the antivaxxer movement—it is not shocking that the more extreme segments of the wellness industrial complex emerge with their vitamin boosters and weaponized gear to storm the US Capitol, as happened on January 6, 2020. Alan Hostetter, a former police chief turned Reiki-master, was one of many joining the violent riot: he went from posting "sunset gong meditation" videos on his YouTube channel one moment to calling for traitors to be "executed" in front of the Capitol the next.[24] Conspiracists have proven organized and more than willing to turn their alt-world into a reality for the many by force, and the wellness industrial complex is a prime source of recruitment and organizing.

Conspiring the Climate Conspiracy

There are many *good* reasons to storm the Capitol and other centers of power: to demand the end of climate crimes, colonial reparations, and planetary wealth redistribution, for example. Furthermore, there are real conspiracies out in the open, but these remain unaddressed by those producing conspiracist climate propaganda because it doesn't suit their political agenda or financial interests. An actual climate conspiracy, for example, is the 1978 internal report by Exxon Mobil researcher James Black, who concluded that carbon emissions were indeed warming our planet, projecting an unlivable world in the near future if not stopped.[25] Instead, the fossil fuel elite started a multimillion-dollar operation to hire scientists willing to refute

its own collected figures, while plotting new trade routes to benefit from the very climate crisis they were causing, such as the melting of the Arctic. Much of this work was done, like the "NIPCC," under the guise of an organization that sounds like a sustainable transition body: the Global Climate Coalition (1989–2011). The GCC's "holistic" logo in which the organization's name encircles a regenerated green and blue globe, instantly signals well-meaning conservationism, and can be considered a graphic milestone in strategies of greenwashing. These methods have continued to be used relentlessly: after the passing of the Paris Climate Agreement, ExxonMobil, Shell, Chevron, BP, and Total invested over a billion dollars in shareholder funds in lobbying and misinformation to avoid government regulation.[26] So, yes, transnational fossil fuel corporations are certainly conspiring.

And what about the military-industrial complex, given that the Pentagon is a conspiracy favorite? For a long time, the environmental costs of the US military were kept a secret. The 1997 Kyoto Protocol—precursor to the Paris Climate Agreement—did not compel the armed forces to disclose their carbon footprint, even while the world's armies combined create 6 percent of all global emissions.[27] The millions of barrels of fossil fuel the US Army consumes yearly for its machinery equals the carbon footprint of Portugal, while the carbon costs of producing

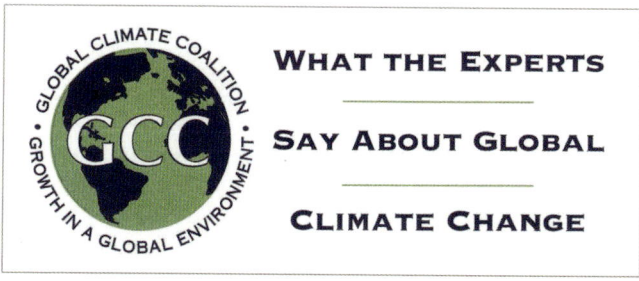

Logo and slogan of the Global Climate Coalition (1989–2001), of which Exxon was a founding member. GCC operated as an international lobbyist group of businesses to challenge the science on global heating.

87

its equipment equal the annual carbon footprint of the Netherlands.[28] This still excludes the calculation of the carbon costs of its supply chain and, most of all, the environmental cost of war itself. The decades-long impact of Agent Orange in Vietnam, the burning oil fields of Iraq, the ecological destruction caused by protracted bombing campaigns, and continuous military drills and tests all add up to incalculable climate violence against people, nonhuman animals, and plants. And then there is the strategic benefit of waging wars against countries to take control of their fossil fuel resources and the use of the military to protect fossil fuel assets across the world.[29] So, yes, the military industrial complex is certainly conspiring.

Or we could talk about Big Tech, another central villain in contemporary conspiracy narratives. A 2021 report focusing on fifty-six tech companies, including IBM and Google, found that half of their greenhouse emissions were not disclosed.[30] While trillion-dollar Big Tech companies such as Apple, Amazon, Alphabet, Meta, and Microsoft have made various pledges to become carbon-neutral between 2025 and 2050, only a fraction of their budgets are focused on propagating climate policy.[31] Data centers, the spill of Big Tech, are projected to consume up to one-fifth of global electricity by 2025.[32] This is not even taking into account the carbon costs of tech manufacturing, the impact of its waste, and the brutal labor practices and ecological impact of mining the Global South for minerals: 54 million tons of so-called e-waste were dumped worldwide in 2019 alone, releasing highly toxic metals such as mercury, lead, and cadmium into the ecosystem.[33] These companies' pledges to shift toward renewable energy are not unproblematic either: infrastructure for renewables equally relies on mining, and many "clean energy" centers—such as Iceland—are largely bought up by Big Tech, turning an industry aimed at supposed sustainability into a pollutant. So yes, Big Tech is certainly conspiring.

And what about Big Pharma? Taking the most mediatized example, the development of COVID-19 vaccines was publicly funded, but patents remain with the manufacturers. Countries

in the Global South that requested that patents be dropped so as to develop or produce the vaccines themselves were denied access, leading to further mutations of the virus and millions of deaths, as well as creating further dependency on the already powerful companies as the pandemic rages on.[34] It is a process not dissimilar to GMOs and the patented seedbanks with which corporations like Monsanto—today part of the trillion-dollar company Bayer—maintain control over the seed market and sow the perpetual dependency and indebtment of small farmers.[35] So, yes, Big Pharma and Big Agriculture industries are certainly conspiring.

The change of climate could be our opportunity to transform these bare conspiracies—those that are out in the open, well documented, and fundamentally exploitative—yet the conspiracists propagate the anti-globe of the alt-world instead.

Take Back Control

Herein lies the central paradox to conspiracy climate propagandists: they tend to be wrong about why they're right. Living in societies plagued by rising authoritarianism, structural racism, global precarity, and climate collapse creates fundamental anxiety and a sense of no control, on individual and collective levels, because indeed, we—most people on the planet—hold no collective ownership over the means of production of the present, nor that of the future. The world emerging in front of our eyes is one of ruins. To confront and change it requires that we engage in the long, hard work of collective organizing, and not to fall for the Brexit myths that to "take back control" we must simply retreat on our islands and blame (poor) immigrants and people of color—those hardest hit by climate catastrophe. But confronting those in power, those actually conspiring, means addressing the complex entanglement between political, economic, and legal systems, and is extremely dangerous. The thousands of disappearances of Indigenous peoples

and activists fighting deforestation in Brazil, or corporate land crimes in the Philippines, are proof of this.[36] As with all collective organizing that challenges and contests power, it often comes at a life or death cost.

Conspiracist climate propaganda instead proposes something of a spiritual quest: joining the antivaxxers, QAnon, or the Flat Earth Society means that one is no longer part of the millions of "masked sheeple."[37] You are "red-pilled," referencing the red pill offered to the fictional character Neo in *The Matrix* that allows him to see the robot conspiracy that maintains his day-to-day illusion of reality. And it is a question not exclusive to the extreme right, as wellness "progressives" are not immune to the anxieties with which conspiracy climate propaganda appeals. Even critical filmmakers, such as Adam Curtis, who meticulously deconstructed the history of propaganda mechanisms in mass psychology and mainstream media through the figure of Edward Bernays, founder of the field of public relations, in his documentary television series *The Century of the Self* (2002), has increasingly turned to weaving fatalistic webs of the all-powerful for whom we are mere guinea pigs in a planetary social experiment orchestrated by neoliberal governments, Big Tech, and religious fundamentalists.[38] And while Curtis edges—or cinematically plays with—the conspiracy form, former progressive propaganda researcher Mark Crispin Miller—who wrote a key introduction to the work of Bernays—has turned from conspiracist analyst to an all-round conspiracist who claims Biden stole the 2020 election, Black Lives Matter is a CIA-staged organization, and "coronafascism" aims to bring around the Great Reset.[39] As (former) progressives equally experience a devastating loss of control over the mechanisms that shape the world and conspiracy can be misread as a critical or even subversive stand, they too prove susceptible to the allure of the conspiracist's spiritual quest: you might not be able to change anything, but at least you are one of the few who see the truth.

Belief in a conspiracy gives the illusion of agency in a world that denies real agency at every turn. You seem to regain control

over your place in the world. You are validated. History will not pass you by without caring whether you live or die. Instead, you are the whistle-blower, the one who removes the curtain for all to see. The para-ecology of flat Earth theory, alien government infiltration, GMO mind control, and vaccine totalitarianism forms an alt-world that gives the initiated a home, a sense of place where they can once again decipher right from wrong, good from evil. It allows followers to become the storytellers, instead of having to live the stories told to them by those with power. It denies the collapse of the climate, and instead recruits rogue scientists and researchers to create an entirely new ecosystem. The promise is this: a home in a world that made us homeless, an ecosystem in a sea of ecocide.

4 *Ecofascist Climate Propaganda: Extinction Supremacy*

Humans Are (Not) the Virus

The heavily armored gold-plated arm of Thanos appears on screen, an appropriated image of the cosmic supervillain from the Marvel superhero film franchise *The Avengers*. In the original series, Thanos "solves" what he considers a multi-galaxy climate crisis of overpopulation by annihilating half of all living beings in the universe. In this video, however, Thanos's bulldog-like face is replaced with that of Donald Trump, who adopts the character's words "I'm inevitable," before, with a snap of his fingers, he annihilates all his political opponents, including Nancy Pelosi and other members of the Democratic opposition, turning them to ash.

This scene is from a 2019 official Trump War Room reelection video, built on the growing popularity of the hashtag #ThanosDidNothingWrong that emerged on Reddit and other online platforms. It capitalizes on the idea that the climate crisis and its consequences are less a problem of systems and ideologies,

Still from the "I'm Inevitable" Trump War Room campaign video, depicting Trump as the *Avengers* character Thanos, 2019.

but rather of overpopulation. Instead of siding with imperialist Marvel superheroes like Captain America and Spiderman, it was suddenly Thanos who was pitched as the voice of reason—interplanetary genocide being sold as an immediate pathway for overcoming resource scarcity and reducing carbon output.[1] Reddit members even initiated their own celebratory Thanos extinction event by joining a list of users of which half would be removed from the platform at random, digitally performing the cleansing of the world population.[2]

Thanos's selection method of who was to die was indiscriminate, random. But it is precisely that random aspect that did not hold up for long. During the COVID-19 pandemic, an ecofascist slogan became popular claiming that "humans are the virus," embodying the claim that higher growth rates in the Global South are the true threat to an inhabitable world. This in turn bypasses the fact that it is the excessive consumption and endless extraction by the Global North that lies at the heart of ecosystem breakdown—rich countries make up only 12 percent of the global population but are responsible for 50 percent of global emissions.[3] In this ideological perspective, Sherronda J. Brown makes clear, it is not that *all* humans are the virus,

but rather those who supposedly engage in more reproductive activity: the Black and brown people of the Global South.[4] This becomes terrifyingly clear in the case of the 2019 Christchurch mosque shootings in New Zealand, in which the self-declared "ethno-nationalist ecofascist" Brenton Harrison Tarrant murdered fifty-one people. Tarrant was explicitly motivated by the "great replacement" theory, the idea that mass migration and Black and brown "overpopulation" culturally and demographically erodes white power.[5] In his manifesto "The Great Replacement: Towards a New Society We March Ever Forwards" (2019), Tarrant emphasizes environmental protection and the need for the preservation of a "natural order." Like Trump, he considers himself "inevitable" in imposing the genocidal specter of ecofascism upon the (racialized) human "virus."

Liberals often think that the right's climate denialism is a problem, but, cynically, recognition of the climate catastrophe on the part of the right could be even worse, when the specter of ecofascism arises along with its main questions: Who has the divine right, the racial superiority, to survive, and who does not?[6] With this in mind, Trump's campaign video can be considered the start to the new twenty-first-century ecofascist climate propaganda campaigns to come.

The Overpopulation Myth

It would be wrong to think that alt-right actors are the only ones who are susceptible to the overpopulation narrative; the ecofascist myth risks contaminating progressive liberal discourse just the same. Think of the film *Planet of the Humans* (2020), produced by Michael Moore and directed by his long-term collaborator Jeff Gibbs, which was launched online during the first waves of the COVID-19 outbreak. The film claims to advance a legitimate critique of "green capitalism," but instead uses dated research and misplaced image sources to argue that it requires more fossil fuels to produce solar- and wind-powered energy resources than humans can ever hope to generate—a

narrative that was quickly embraced by the ultra-right media outlet *Breitbart News*.[7] And while there is certainly much to say about the environmental cost of so-called sustainable energy and the necessity to dismantle the myth of "progress" underlying consumer society as well as the idea that current energy expenditure is compatible with a "renewable" future, Gibbs instead claims the real issue at stake is overpopulation, because "our human presence is already far beyond sustainability" and "it's not the carbon dioxide molecule destroying the planet, it's us."[8] But population growth in the Global North is at an all-time low, while energy consumption is unsustainably high, which then automatically points the finger at the higher population growth in the Global South, whose consumption rate is infinitely lower.[9] The racialized myth of overpopulation bypasses the fact that it is not human population but the global capitalist system that is not ecologically sustainable, enabling the murderous eugenics that inform ecofascism to gain legitimacy in wider discourse.

Ecofascist climate propaganda racializes climate breakdown, and that is not different in the case of the climate crisis–induced coronavirus pandemic,[10] which was quickly declared the "China virus" by Trump, fueling racially motivated acts of violence against Asian American people and Asian migrant communities worldwide. In a similarly racializing act, Hungarian prime minister Victor Orbán claimed that migrants and refugees were virus-carrying vessels—and, thus, a virus themselves.[11] The equation of bodies of color with disease aiming to penetrate the sovereign national body follows textbook propaganda strategies used in Fritz Hippler's Nazi faux-documentary *Der Ewige Jude* (1940), in which rats and other supposed "vermin" were used to allegorize the Jewish "plague" in Europe. Various Hollywood pandemic movies have laid the groundwork for the successful racialization of the pandemic as well. Whether it is the Motaba virus modeled after Ebola in *Outbreak* (1995) or the MEV-1 virus modeled after SARS in *Contagion* (2011)—in these and other cases, the virus always originates in a "foreign" body.[12]

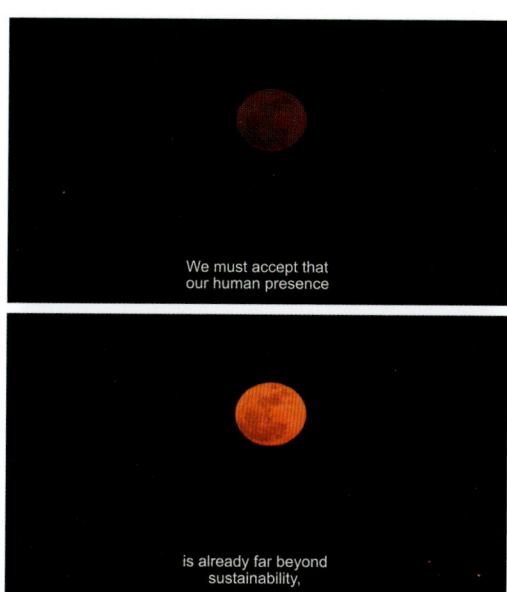

Jeff Gibbs (dir.), *Planet of the Humans* (2020), stills.

In the zombie pandemic blockbuster *World War Z* (2013), directed by Marc Forster, the most telling scene is the arrival of survivors of a zombie plague to Israel, whose US-subsidized weapons and surveillance industry have made it the rare world actor capable of withstanding the contagion—a scenario that obviously aims to legitimize the maintenance of the occupation of Palestine and its foreign support in the present. In the film, it is high-pitched singing by Arab refugees who have been benevolently taken in by the occupier that finally triggers the hordes of zombies to overtake the Israeli fortress despite all precautions, proposing the deeply offensive and revisionist narrative that it is essentially Israeli altruism that forms its true vulnerability.[13] This goes hand in hand with the unequivocal framing of Palestinians as an unworthy zombie race beyond redemption.

This kind of pandemic cinema has further propagated certain behavioral responses in viewers, in which democratic rights become identified as unsustainable luxuries during a crisis and are quickly replaced by centralized response and mass securitization. Another zombie-type virus depicted in Danny Boyle's film *28 Days Later* (2002) shows how unaffected human survivors become a greater threat to one another than the infected zombies are to them. From "humans are the virus" we move to "humans are the zombies." In Alfonso Cuarón's more allegorical infertility epidemic *Children of Men* (2006), people are expected to fend for themselves by hoarding food, medicine, and weapons, and to trust the governing regime in imposing brutal securitization measures, praying that they are exempted from the worst consequences, while elites save cultural treasures to gaze upon in their securitized private bunkers.

It is not difficult to see the parallels between these popular imaginaries and the framing of certain humans as the virus, that together prepare viewers for the cultural acceptance of the specter of ecofascism and its genocidal forms of authoritarian control, population management, and extermination. The mass hoarding at the start of the COVID-19 pandemic in the Global North—that left supermarkets devoid of canned food and toilet paper—are a direct expression of what citizens have behaviorally come to expect of themselves through these cultural imaginaries. What begins as an ecofascist climate propaganda narrative becomes behavioral reality. From imagining a different reality, we move toward its actual construction.

The Extinction Sublime

The ecofascist overpopulation myth provides a sense of release: no longer do we need to organize collectively to confront complex systems and their long-term inheritance in the form of feedback loops that wreck the world in common. Instead, it expands on the Nazi vision of a "final solution" in the form of a systematic planetary murder campaign: extinction to combat extinction.

But there is a deeper desire at play here as well. The rise of the extreme right can not only be explained through economic conditions of precarity. Such a focus on economic rationalization sidesteps the perverse joy that fascism provides: the joy to hold power over others, to be able to exclude them, decide their fates, lives, and deaths, on a planetary scale.[14]

This perverse joy—fascist joy—includes the experience of both terror and attraction that emerges from imposing violence on people and the environment at large, what I would call the extinction sublime.[15] Many have experienced this sense of awe and frightful joy gazing at the overpowering collapse of systems of life support in disaster movies. The eco-apocalypse film *The Day after Tomorrow* (2004) by Roland Emmerich, based on Art Bell and Whitley Strieber's book *The Coming Global Superstorm* (1999), is exemplary in this regard. In the film the sudden breaking of ice shelves on the Antarctic Peninsula coincides with three superstorms that send the Northern Hemisphere into a new Ice Age. As millions die in giant hailstorms, mega-floods, and advancing glaciers, a NASA astronaut looks down on Earth from the Space Station and remarks: "The sky never looked so clear."[16] The underlying narrative is that massive population death and forced migration would regenerate the Earth, an idea that has been shamelessly replicated during the coronavirus pandemic when, due to reduced industrial productivity, various media outlets seemed overjoyed at the sight of reduced smog in cities as mountains and skies came back into view and wild animals began to reappear in cities: if only we—the virus—retreat, "nature" and "balance" will be restored. On the liberal side of things, this then got reinterpreted as "nature is healing" misinformation, such as the viral story of dolphins supposedly having "returned" to the canals of Venice.[17]

But the extinction sublime shows us that it is not only the vision of a cleansed world that is a driving force for ecofascism. It is equally the joy of seeing it being torn apart. The growing number of visual graphs and climate catastrophe maps published by mainstream media seem to operate as a perverse cinematic doomsday clock fueling this sentiment. With one and a

half degrees of warming, such and such islands disappear. With two degrees of warming, this certain city's coastline floods. With three degrees of warming, the following countries are turned to ash. At four degrees, the following continents can no longer be inhabited.[18] This imagery places viewers in a fictional bird's-eye-view situation room overlooking the near future. The extinction sublime places us falsely in charge, while being overwhelmed by both the horror and pleasure of watching sinking continents. This might be the ground zero of the nature versus human divide, in which we are both in control over nature—external to it—and simultaneously in awe of the powers we release within it. This combination of awe and destructive joy assumes a position in which the extinction sublime is witnessed, but not *lived*—it happens elsewhere, to others. And this places the onlooker firmly in an imagined observatory of ecofascist supremacy: a place where no harm can come. For "we" might all be the virus, but some are more contagious than others.

This might seem counter to the obsessive destruction of capital cities in the Global North that always fall victim first in the never-ending succession of climate disaster films like Los Angeles in *Earthquake* (1974), New York City in *Deep Impact* (1999), or the entire United States and additional countries as set-piece extras in *2012* (2009). But this amounts to nothing but a climate haunted house for the Global North, as its inhabitants know very well that what is cinematically transposed as an exception to New York City is in fact the daily reality in, for example, the Philippines plagued by increasingly brutal typhoons, or India drowned by ever-expanding monsoon seasons, or cyclones ravaging Fiji, or apocalyptic locust swarms tormenting Kenya. This amounts to whitewashing the climate crisis.

The most cynical example of this might be the film *The Impossible* (2012), directed by J. A. Bayona, depicting a white US family enjoying a luxury holiday in Thailand when the country was hit by the 2004 Indian Ocean tsunami that killed near a quarter of a million people in fourteen countries. There is nothing "impossible" about such disasters affecting the poorest communities

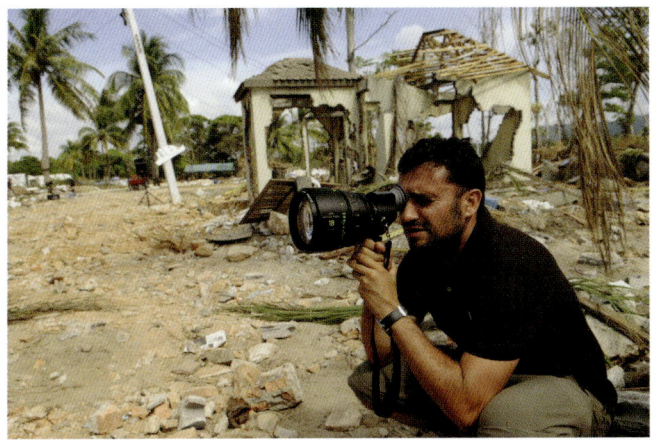

Director Juan Antonio Bayona on a set in Thailand that reconstructs the massive damage caused by the 2004 Indian Ocean tsunami, shooting his film *The Impossible* (2012). Landmark Media.

of our world every single day, and it is telling that in order for the story to be told by Hollywood, the original account of the disaster by a Spanish tourist had to be turned into an all-white American one, though still directed by a Spanish filmmaker.[19] The possibly single genuine scene in the film depicts the white family, having scrambled their children together, leaving by plane while looking out of the window over a drowning world. The extinction sublime for them is to watch from their airborne situation room. To them, it remained *impossible*, even when they lived it themselves.

For ecofascist propaganda to gain popular support in bringing about its genocidal worldview, it must thus cultivate the profound belief that the white class will remain unaffected—or, at the very least, will survive. They might feel the behavioral need to hoard toilet paper and canned food, but not oxygen and water. Their privilege might be partially compromised, but that is a minor cost for remaining the racially designated rulers of what will remain of the world.

Ecofascist Necrospheres

Through a racialization of the climate catastrophe and the fascist joy generated through the extinction sublime, ecofascist climate propaganda results in the propagation of necrospheres. The word "*nekros*" derives from Greek and means "corpse," and the term "necrosphere" is used to describe the layers of dead matter in a biosphere. But in the case of ecofascist climate propaganda, the necrosphere no longer is part of a larger ecosystem, but represents what remains of a world ruled by death and planned extermination, a world structured on what philosopher Achille Mbembe has termed *necropolitics*.[20]

But how can we grasp the breadth of potential ecofascist necrospheres when they are being built or contemplated as we speak? Colonialism created its first foundations, sowing death by transporting infectious diseases and through murder, enslavement, and mass extraction. Mass extinction of cultures and life forms were the result, and these initial terrifying ruins are the foundations of today's ever-expanding necrospheres. And connections between colonialism, fascism and ecology are not something exceptional to our time. Nazism propagated its own version of racial environmentalism through forest conservation, the reduction of air pollution, and by combating industrial impact on crop production—all while mounting a massive industrial machinery for total war, intercontinental colonization and mass extermination.[21] But the climate crisis, at the scale at which the Global North is now beginning to understand it, did not yet play a role in the ecofascist propaganda of the recent past. Now, however, we see how the far-right's denial of climate catastrophe is shifting toward using ecological crisis to further their own genocidal agendas. In order to grasp the scales and scopes of the necrospheres during this century, we should thus study (critical) case studies of the *future* as well. Using cultural examples from the past and present, here I shift toward the field of critical climate fiction, ranging from film to graphic novels and literature that depict the death-worlds that ecofascism will bring about. Such examples are thus not ecofascist in

themselves; precisely to the contrary, they narrate necrospheres not to propagate them but to propagate against them. And by studying them, we can better understand how not just to organize in the future but to organize against necrospheres already in the making.

In Octavia Butler's diptych *Parable of the Sower* (1993) and *Parable of the Talents* (1998), for example, she describes the United States in the 2030s as a deeply polluted landscape plagued by extreme weather, in which warring gated communities exist in a perpetual civil war, tech corporations engineer contracts for lifelong serfdom, and countless peoples try to flee northward in search of safer grounds. It is a world inherited from a crisis known as "The Pox," (short for "apocalypse"). It's a disaster for the many, but a perfect moment for the ecofascist few to build their following. In Butler's book, the propagation of the necrosphere is in the hands of Texas senator Andrew Steele Jarret, the presidential candidate of the Christian America Movement, campaigning with the slogan "Make America great again!"[22] As observed by one of the book's characters: "Jarret insists on being a throwback to some earlier, 'simpler' time. *Now* does not suit him. ... There was never such a time in this country. But these days when more than half the people in the country can't read at all, history is just one more vast unknown to them."[23] Jarret employs the propaganda narrative of ultranationalist retro science fiction, projecting the image of a mythical past of national stability, white male supremacy, and religious piety: he promises his followers the fascist joy of the extinction sublime by cleansing the world and ruling over its ruins.

But as in the case of our present, such master narratives might refer to a world that never existed, but that does not mean they cannot be performed into reality. Once elected, Jarret begins a Christian American crusade to construct his ecofascist necrosphere by cleansing the United States of non-Christians, turning their bodies into a resource for a new era of slavery through the use of technically advanced shock collars. The rising popularity of so-called Dreamasks, which provide access to a virtual reality metaverse, gives testimony to the remaining population's desire

to escape the nightmare they themselves voted into power. In Butler's narrative, the ecofascist method of fighting extinction with extinction manifests as a dual cleansing, physically and mentally. Those considered as the virus—the nonwhites, non-Christians, women, or any type of nonconformist—are either physically exterminated through murder or exploited through enslavement. What remains of a meaningful collective consciousness is made extinct through the Dreamasks.

In Butler's books, we witness the building of the ecofascist necrosphere by Jarret and his followers. In Bong Joon-ho's film *Snowpiercer* (2013), however, it has already been created. Based on the graphic novel series *Le transperceneige* by Jacques Lob (1982–2015), the movie depicts the world following a mass extinction event that has led to a new Ice Age. Only a few thousand humans have survived, all housed in a self-sustainable necrospheric bullet train known as the Snowpiercer that travels around the world in endless circles. Designed by a character known as Mr. Wilford and his company Wilford Industries, who foresaw the mass extinction event, the train is tightly stratified and segregated. Disposable workers are housed in the back of the train and used for cheap labor, and in some cases literally as spare parts for the machine. The cars in the front are occupied by upper-class inhabitants, housed in nostalgically wood-crafted wagons and able to enjoy a luxurious clubbing scene and delicate sushi dishes. Some wagons replicate natural environments—if only to grow food—evoking an image of a stretched and mobile version of the Biosphere 2 facility. Similar to Butler's description of the Dreamasks' use as techno-population control, a drug known as "Kronole" is circulated among the train's upper echelons to repress their complicity in the death-world that grants them their apocalyptic privileges.

As Mr. Wilson explains: "this train is a closed eco-system. ... The air, the water, the food supply, the population, must always be kept in balance."[24] Just as the necrosphere train is entirely engineered, so too must Mr. Wilson's "natural" order be forcefully maintained: "We don't have time for true natural selection, we would all be hideously overcrowded and starving waiting for

Illustration from Jacques Lob's graphic novel *Le transperceneige* (1982–2015). © Casterman.

Bong Joon-ho (dir.), *Snowpiercer* (2013), still. Weinstein Company/Courtesy Everett Collection.

that."[25] Thus, military units directed by the front leadership of the train regularly move toward the back to execute the "overpopulated" segments. Ecofascist necropolitics, in Wilson's conception, is one that adjudicates worthy and unworthy humans.

In both of the ecofascist necrospheres described by Butler and depicted by Joon-ho, we see the core narratives of ecofascist propaganda unfolding. Climate catastrophe and the social instability it causes are exploited by genocidal visions that promise a return to a "natural" order in which ecofascist followers are provided the joy of extermination and the privilege of survival. In the death-world that follows, governance is replaced by extinction management, both in the form of the physical destruction of disposable humans and in wiping out the threat of social consciousness through Dreamasks and the Kronole drug.

The critical climate fiction of Butler and Joon-ho is essential to grasp the realities ecofascist propaganda aims to bring about, although the explicit character of their necrospheres can also be deceiving. In Elvia Wilk's novel *Oval* (2019), for example, the ecofascist death-world is described in such proximity to the Global North's present reality that it can hardly be considered a mere what-if scenario. In Wilk's book, there is no central authoritarian leader like Jarrett or Mr. Wilson. Instead, we are situated in an eerie near-future Berlin haunted by unpredictable weather, where most residents work temp jobs or as flex consultants for corporations. Those who remain of the artistic and cultural community are hired on a consulting basis by these same companies to extract their creativity to heighten productivity. In this landscape of perpetual precarity—in terms of both a precarious climate and precarious labor—we follow the protagonists Anja and Louis trying to navigate their perilous lives in a geoengineered environment known as the "Berg": a fake mountain covered with malfunctioning, experimental eco-huts. In Wilk's world, liberal greenwashing doctrines and exploitation merge in an ultracompetitive soul-crushing landscape.

If the artist consultants populating Berlin die before the terms of their contracts have ended, their dried heads are exhibited in their investors' private vitrines: a form of "death as

currency," as one of the novel's characters remarks.[26] No great authoritarian leader is needed to transform a living world into one managed by death, by necropolitics, where the value of life is equal to the amount of service a body is able to provide before exhaustion. Neoliberal precaritization combined with doctrines of enforced sustainability suffice. And in Wilk's world as in the other two examples, a drug takes central stage. In a necrosphere beyond care, a pill known as Oval designed by Louis fabricates the experience of generosity by those who ingest it. Under extinction supremacy, retreating into a "pharmacological utopia" is the last escape for the barely living, the living dead.[27]

The Death Form

These narrations describe not life forms, but death forms. They come into being through political narratives of retro science fiction: Andrew Steele Jarret's "Make America great again" promises a return to an idealized past sovereign white religious nation that never existed in the first place, but that is presented as a common future. Mr. Wilson engineers the class composition of his necrospherical train based on his idea of a fundamental "natural" order that needs to be conserved and turned into the future for the remnants of the human population. The central notions of order and balance that dominate their ecofascist necrospheres are in no way "organic" but structurally enforced, just like the terraformed Berg in Wilk's near-future Berlin. "Natural selection" does not equal some kind of cyclical process but is entirely managed in the form of the execution of undesirables on the Snowpiercer train, or the collection of shrunken heads of precarious consultants in Wilk's world.

And what remains of a world in the ecofascist necrospheres for those lured in by the extinction sublime and the promise of racial exceptionalism proves fundamentally unbearable. Just as opium formed the foundation of colonial modernity, its production and trade providing financial resources for the empires, similar techno-pharmacological equivalents are all that is left in

the ecofascist endgame, whether Dreamask, Kronole, or Oval.[28] The ecofascist joy that annihilates the living worlds of the many leaves a crumbling death form of a world for those who remain: a world in which one resides only to be able to escape from it. A wreckage of a world for the living dead, now declared "true nature" for those that benefit from ruling over its remains.

So how much of the ecofascist necrosphere is under construction today? For now, many authoritarian governments and parties have doubled down on climate denial instead. Authoritarian governments might opportunistically equate refugees of color with COVID-19, but they refrain from acknowledging the pandemic as being linked to climate catastrophe. But in the political fringes slowly but surely becoming mainstream, ecofascism and its militia are certainly propagating, and their genocidal rhetoric finds increasing resonance in political discourse, as the Trump ecofascist propaganda video shows us. The question then is when—not if—their discourses and tactics will be adopted by dominant far-right parties and governmental institutions. Its potential mechanisms are already clear for all to see.

Think of the 2022 Russian invasion of Ukraine, the start of a war in which resource scarcity and control play an important factor. Different from the case of the millions of Syrian refugees denied from seeking safe harbor in Europe, white Ukrainians were welcomed with exceptional ease by neighboring European countries. Authoritarian governments like that of the Law and Justice Party in Poland and Orbán's Fidesz party in Hungary—which had refused EU refugee quotas for refugees of color and had begun to erect massive lengths of Trumpian border walls of their own—were now the first to organize humanitarian aid and declare their "solidarity." But not for everyone. Black Ukrainians and Ukrainians of color, Ukrainian transwomen and transmen, and international students and workers of color were refused entry into countries like Poland—some reported to have been held at gunpoint and beaten by police and security personnel as they tried to access trains and buses for evacuation.[29] We have to face the fact that the racial right to survive the climate collapse will be enforced by these same governments when faced with the

arrivals of millions of climate refugees: only those that fit their white supremacist heteropatriarchal agenda will stand a chance.

What Octavia Butler, Jacques Lob, Bong Joon-ho, and Elvia Wilk make visible is the space between the present and the future. This is a space that requires a kind of deep material and ideological speculation, building from real-time processes and narratives of the present, extrapolating them into the future, while keeping in mind that our imagination of crises always lacks the depth of its actual materialization. There is, in other words, a "rogue" dimension to the imagination. The War on Terror, for example, imagined a world of perpetual security, but as a result of its own violence generated ultraviolent actors, such as the Islamic State, which were previously unimaginable as an organization.[30] So while it might be true that in order to change the world, we have to imagine that change first, we simultaneously have to learn to imagine the depths of violence and disaster that make this world and, without the propagation of a radical alternative, will unmake its future. Cultural work can cross and shape that space between the present and future. Its speculative propagations allow us to propagate differently against the threat of the ecofascist necrospheres. The step between the fascisms that tear the world apart at present and the ecofascisms that aim to rule whatever will remain of it in the future is terrifyingly small. The points of overlap between Trump and Jarret, or between Mr. Wilson and Orbán, are negligible: many are already living their necrospheres in the making.

5 Transformative Climate Propaganda: Against Extinction

Green New Deal Time Portals

Imagine you're standing in an observatory, overlooking different town squares and parks from up high across the territories of the United States, from Pelham Bay Park in the Bronx, New York, to Plaza del Totem in San Juan, Puerto Rico. But something has changed in their appearance. Overhead planes and cramped traffic have disappeared. The squares have been forested, booming with bright tree life, as fountains and riverbeds now crisscross the landscape. These urban reforestations do not seem allergic to technology, as in between the skyscrapers that emerge from the greenery, windmills mark the skyline. High-speed electric trains slide silently through the landscape. Winding pedestrian paths are bustling with people playing, walking, and biking. Monuments, such as the Queens Unisphere constructed for the 1939 World's Fair and San Juan's forty-foot totem that symbolizes the origins of the colonized Americas, quietly overlook a world transformed. The world of the *Green New Deal*.

The Green New Deal poster series by Tandem (2019), directed by Scott Starrett in collaboration with Gavin Snider, Dayi Tofu, and Lazarus Nazario. Courtesy of Tandem.

These images are part of the Green New Deal poster series, a campaign initiated by US Congresswoman Alexandria Ocasio-Cortez in collaboration with communication design studio Tandem, directed by artist Scott Starrett. Its aesthetics refer to the serigraphic posters commissioned through the Works Progress Administration (WPA) of the New Deal era, in particular those celebrating public parks. These images became a cornerstone of a new kind of publicly owned art: art not just depicting public spaces—like the national parks—but expanding our image and cultural experience of public space as such. Crossing through these vintage-styled landscapes are tech-futuristic infrastructures, where the language of the New Deal meets high-speed bullet trains and solar energy in a new hybridity between real gains of the past and potential resonances with the future.[1] These posters depict a world that becomes possible if the Green New Deal—a legislative proposal filed in the US House of Representatives by Ocasio-Cortez and her fellow Democratic representative Edward Markey in 2019—were passed.[2] Its aims are to achieve net-zero greenhouse gas emissions; massive investment in sustainable energy that would boost a new unionized green job market; equal access to healthy food, clean water, and air; mobility for all to travel through a regenerated world; and recognition of frontline Indigenous communities and communities of color disproportionately impacted by the climate catastrophe. The Green New Deal poster series thus operates as a time portal: each poster is a window into a world that becomes possible if we dare to imagine change, and if we dare to mobilize and organize collectively to transform that imagination into a new, shared reality.

The name references the New Deal spearheaded by President Franklin D. Roosevelt that consisted of a massive investment program between 1933 and 1939 to pull the United States out of the Great Depression. It brought about regulation of the banking sector and massive investment in public housing, while also enlivening the job market through the rejuvenation of infrastructure and commissioned public art projects. But it

also excluded many Black communities, communities of color, and Indigenous communities from its policies.³ That darker heritage of the New Deal poses a crucial question for the Green New Deal's ideal of a "green industrial revolution" depicted in the posters. Therefore, its proponents, such as Ocasio-Cortez, Yanis Varoufakis, and Naomi Klein, emphasize that the repair of the climate must simultaneously include social repair. The climate crisis cannot be separated from social and class injustices: it is the wealthiest in the Global North who pollute the most and benefit from that pollution, while the most precarious are forced to bear the consequences of an increasingly unlivable world.⁴

This social and ecological repair is visualized by artist Molly Crabapple in the video *A Message from the Future with Alexandria Ocasio-Cortez* (2019), presented by Naomi Klein and written by Avi Lewis and Alexandria Ocasio-Cortez. Speaking from a future where the Green New Deal has already been implemented, depicted through Crabapple's paintings and collages, we hear Ocasio-Cortez narrate how impossible this political and economic transformation seemed in our present, compared with how its principles—from sustainable infrastructure to Medicare for All and publicly funded elections—are the new normal in her future *present*. In Ocasio-Cortez's words: "The first big step was just closing our eyes and imagining it. We can be whatever we have the courage to see."⁵

While *A Message from the Future* still places substantial emphasis on a new generation of green industry, its follow-up, *A Message from the Future II: The Years of Repair* (2020), written by Klein, Lewis, and Opal Tometi and released during the COVID-19 pandemic, sidelines the industrial paradigm for a vision of a low-carbon world of care and repair. Now it's not the voice of Ocasio-Cortez, but different voices of future citizens and organizers performed by Tometi, Emma Thompson, Gael García Bernal, and Nnimmo Bassey, that tell us how ecological and social transformation proved possible, again depicted by Crabapple's drawings. It is worth exploring this future imaginary in some detail, in a time in which the end of the world has proven so

Kim Boekbinder and Jim Bat (dirs.), *A Message from the Future II: The Years of Repair* (2020), video still. Image by Molly Crabapple. Courtesy of The Intercept/The Leap.

much easier to propagate compared with even minor reforms to our present, extractivist system.[6]

To explain their future, the narrators of *A Message from the Future II* reach back to our present: the "First Great Pause"—the coronavirus pandemic—"when the smog cleared and the rich fled the cities. When poverty dropped its disguise and racist inequality drew the map of the disease."[7] It is a time (our present) when the world sees who the true essential workers are: the caretakers in nursery homes, the workers in Amazon fulfillment centers, the delivery drivers. But these essential workers are precisely those who are treated as the most disposable, low-paid labor force sacrificed to die for others to live. And the plight of precarious essential workers will only become worse, when in 2023 "super-droughts," "mega-floods," and "hyper-typhoons" force millions of climate refugees on the run and locust plagues spread through the continents, threatening food security. In the video, it is COVID-23 that ravages refugee camps and storm shelters. Political elites only know to respond through austerity to

revive the myth of economic growth, even as the planet shows there is no more growth left.

"The cloud of sickness and death grew, and we couldn't breathe," the narrators tell us, referencing George Floyd's last words—"I can't breathe"—that sparked further mass mobilization of the Black Lives Matter movement in 2020. In 2023, that movement only broadens further, declaring a Viral Rent Strike to stop paying propped-up costs of housing, which in its turn leads to an Essential Workers Strike by delivery drivers, cleaners, and farmers that forces the economy of precarity and austerity to a halt. Violent state repression follows, but the crowds cannot be held, as authoritarian leaders are toppled like the Black Lives Matter movement toppled the statues of colonial oppressors in the years before. A renewed political order is pressured to begin what will become known as the "Years of Repair." Now, the economy is revived by centering unionized, low-carbon, essential work. The mega budgets previously used for policing, prisons, and wars are repurposed to serve food, farming, and care work for young and old. Furthermore, the notion of work is expanded: "nonhuman essential labor"—the work of bee pollinators and plant oxygen–production—is recognized as work and earth workers across the human and nonhuman world unite. A Full Employment Act is implemented, and new worker cooperatives emerge, focused on mental health support, public art, and mass tree-planting campaigns.

A Message from the Future II: The Years of Repair narrates further from the future still: just as the climate can reach tipping points of no return, so can transformative change reach its own tipping points, when everything must change. In the future present, a new digital commons is launched, "vaccinated against surveillance." The fossil fuel economy is dismantled and its remaining profits invested to repair environmental damage. And as pandemics continue to ravage communities, life moves outdoors: schools, theaters, and public celebrations now take place in parks and streets, shaping new public spaces of collective living. Truth and reparations commissions in colonial countries begin the hard work of structurally confronting histories of colonial

violence, and a "Land Back Program" initiates the return of stolen land to Indigenous communities. Their caretaking of the land becomes the paradigm for the new ecology of care in the Years of Repair.

But, as the future narrators make clear, not all can be repaired in the Years of Repair. While the new political and economic paradigm indeed begins to regenerate the environment, viruses have not stopped mutating, extreme weather continues to torment communities, and the world has not ceased warming, as too many tipping points have been reached and feedback loops triggered. The difference? "When they come, we're ready. With our networks of nurses and neighbors. Our small farms and big forests. Our systems of care and repair. No one is sacrificed, everyone is essential."[8]

COVID-23. The narrative is already an archaeology of the future—a future that never happened.[9] Or is it a future like a seed, that still awaits its propagation? Whether or not moments of crises can be turned into transformative momentum depends on our capability to imagine that we can win, and to simultaneously organize in order to make that victory a material reality. This is what Crabapple's art in both videos shows. She allows us to see how she imagines and constructs a future, because we see her paint it. We see the brushes, the cutouts. We see how the image is made, that it is, in a way, not "real," but the fact that despite our being aware of how it is constructed we can still *believe* in what it signifies proves this exact power of organizing—organizing the imaginary.

The two-part *A Message from the Future*, as well as the Green New Deal poster series, introduces us to a paradigm of transformative climate propaganda. Just as disaster capitalism has shown how crisis can be used to further austerity and other forms of economic and military terrorism, the climate crisis can also operate as a catalyst for "disaster care."[10] These are not the time portals of retro science fiction that the far-right prefers, for there is no "solid" world to return to. The climate will continue to change, but we can change with and as part of the climate, to propagate not just survival, but transformation.

Climate Realism

In transformative climate propaganda, we see a manifestation of what we could call *climate realism*. Like the history of social realism, in which artists aimed to represent the struggles of the working class, climate realism aims to make visible the reality of the climate catastrophe, but it equally propagates the realities that could be made possible if social and political systems change with the climate. Alice Guillermo, one of the most important social realist-historians and an organizer in her own right, emphasizes this dual aspect of "realism" in social realism as well: a depiction of the struggle of the working classes, on one hand, and the reality they can construct by acting collectively, on the other.[11] Neither Scott Starrett nor Mary Crabapple are of any illusion that the crisis is not here to stay, nor do they romanticize what that means in terms of the structural devastation that will result in this multigenerational extinction event. It is not "romantic" or naive to imagine a life in the public sphere because the dangers of becoming infected by new viruses inside is higher; rather, it is an attempt to find transformative momentum even in the depths of catastrophe. From disaster capitalism, we move to disaster care and repair.[12]

Such an approach to climate realism that aligns with some of the core ideas of the Green New Deal can further be found in the literary work of Kim Stanley Robinson. While much mainstream science fiction presents readers with an increasingly dominant dystopian normativity in which endless variations of the end of the world are presented in climate-fascist narratives of tidal waves, raging hurricanes, and erupting volcanoes, Robinson's practice of climate realism un-cancels the future in detail.

In Robinson's 2020 novel *The Ministry of the Future*, the focus is on an eponymous intergovernmental agency, founded in 2025 as a sub-agency of the Parties to the United Nations Framework Convention on Climate Change, who have grown frustrated with the lack of action taken on the 2015 Paris Climate Accords. The Ministry of the Future is tasked with representing not-yet-born human, nonhuman animal, and plant life by outlining

transformative legislation for a new planetary politics. But many of its proposals are slowed down due to the prioritization of national and fossil fuel interests, leaving it with limited powers to enforce change.

Like in Crabapple's COVID-23 pandemic, there is a transformative breaking point. In the case of Robinson, it's a massive heatwave that torments Uttar Pradesh, the state along India's border with Nepal. Potable water was already scarce, and in a matter of weeks, the so-called wet bulb event forces the collapse of the electricity grid. Many seek to cool their body temperature by standing in the remaining lakes, but these heat up too, boiling them alive. Millions die. And while Robinson throughout his oeuvre has proven skilled in evoking Hollywood-style grand landscapes of Martian geoengineering and flooded cities, he does not allow any ecofascist joy in his readership; there is no awe in the horror of omnicide. Just horror. It proves that popular cinematic tropes can still be reclaimed and retooled for other purposes.

For the Indian government, the heat wave is a reason to act swiftly and expel transnational fossil fuel companies from their lands, while beginning a geoengineering process by spraying sulfur dioxide into the atmosphere to replicate the dimming heat effect of volcanic eruptions. But nonparliamentary movements begin to act as well. A new network known as the Children of Kali is not willing to wait for billions to die to achieve modest reform, and they employ drone swarms to take down fossil fuel air travel, particularly private jets and business lines. On the event that becomes known as "Crash Day," the Children of Kali take down sixty passenger jets across the world in a matter of hours. Consumers hardly dare to fly after, and the fossil fuel–dependent aviation industry crashes. Energy-neutral experimental battery-powered planes, blimps, dirigibles, and hot-air balloon industries take off instead. The Children of Kali's "War for the Earth"—a counterpoint to extinction wars—has begun.[13]

And it is the Children of Kali's systematic sabotage and destruction of container ships (by torpedo) and mass animal farming (by infecting cattle with mad cow disease) that builds the pressure on existing political and economic systems that

allows the Ministry of the Future to gain momentum. Fearful of total system collapse, central banks suddenly prove amenable to the Ministry's novel ideas, such as the introduction of a "carbon coin": "one coin per ton of carbon-dioxide-equivalent sequestered from the atmosphere, either by not burning what would have been burned in the ordinary course of things, or by pulling it back out of the air."[14] Similar to the time portals of the Green New Deal, once a tipping point is reached, change becomes possible across the board. In this case, the Ministry of the Future essentially becomes a new "shadow government." They initiate the so-called YourLock platform, a cooperatively user-owned form of social media on the blockchain. Credit unions begin to replace banks. New passports for climate refugees are issued. An "Internet of Animals" meant to track animal populations is now used to register them as *citizens*. A new planetary Biosphere and Civilization Health Meta-Index is introduced, replacing the deadly reliance on gross domestic product (GDP).

Robinson's detailed ecosphere of the future resists the dystopic imaginaries of the ecofascist necrospheres that dominate much popular culture, despite its own nihilistic component that suggests that meaningful planetary change can be triggered only by large-scale disaster. At the same time, is that disaster not already present? Have millions not died in colonial conquest, which formed the first phase of disastrous large-scale alterations of ecosystems and the extinction of countless species? Have millions not died in the mechanized terror of the industrial revolution? Are millions not dying today from air and water pollution, murderous extraction sites like mines, or crushed in extreme weather events and drowning on disappearing islands? The fact that these events are *currently* happening, and are not leading to immediate structural change, might make Robinson's vision seem strangely optimistic.

What is essential in *The Ministry of the Future*, however, is that it's not the extreme events themselves that produce change, but people's capability to organize with them, to transform with them. In the case of the Children of Kali—like the Years of Repair depicted in Crabapple's work—putting climate

realism to practice means becoming part of the storm, while also changing its course. Such a transformative climate propaganda narrative aims to install a different cultural imaginary, cultivating a new behavioral response: not hoarding for racial self-preservation, but collective disaster care and repair for collective transformation.

Climate Defense

Sounds of chanting and moaning fill the streets of Rotterdam city center. A troupe of demonstrators dressed in black and green emerge, carrying a large, draped coffin marked by a graphic rendering of an hourglass. Time is up, they say. This is a funeral rite for a dying Earth, whose wailings voice deep climate grief for an ecosystem in ruins. Pedestrians look startled as the slow dystopian march passes by. After an hour, the troupe assembles at one of the city's main crossroads where a massive, dark green, eight-meter-high polyester sculpture representing melting human figures hanging from a stack of eighteen oil barrels is located. This artwork by Joep van Lieshout is titled *Cascade* (2010) and is supposed to represent human addiction to oil.[15] Normally, it stands passively on one of the busiest intersections of the city as cars drive by, confronting, according to its commissioners, consumer society in its heart.[16] But no one feels confronted and its supposed message is rendered mute and defunctionalized. Now, the sculpture comes alive as the choreography of mourning changes and grief turns to anger. Participants climb up the artwork and roll out a large green banner that reads "Climate change is murder." Within an hour, grieving the world is transformed into a rebellion for a living world. *Extinction Rebellion*: the living propagating against extinction.

Founded in England in 2018, Extinction Rebellion—or XR for short—is one response to the question of what it means to become *part* of the storm of climate crisis. This self-declared nonviolent civil disobedience movement brings climate realism into practice in the here and now and organizes through direct

actions that aim at the maximum interruption of fossil fuel economies. XR members glue themselves to the entries of airports to block people from entering and climb planes to stop them from taking off. They blockade intersections to interrupt the hyperproductivity of traffic flow and consumer logistics. They stage "die-ins" where protestors lie on the street mimicking the future dead of the climate catastrophe, or chain themselves to cars and trucks obstructing roads. XR is a "swarm," operating through small groups creating maximum-impact blockades at as many simultaneous locations as possible to wear out police forces incapable of processing all the necessary arrests of so many small collectives, grinding the extractivist system to a halt.

XR seeks to bring mass attention to the climate crisis and demands that governments declare climate emergencies and cut emissions to net zero by 2025. Having researched successful mass movements of the past, its data-driven organizing work is based on the conviction that mobilizing 3.5 percent of the population through momentum-driven actions can result in the critical mass necessary to force governmental institutions to give in to its desire for "citizen's assemblies" to decide future climate policy.[17]

Extinction Rebellion's cyberpunk aesthetics are a striking component of the movement, emerging from these urban swarms like the biker gang backdrops in the apocalyptic *Mad Max* film series. Its futuristic piracy takes the form of acrobatic towers or pirate boats that suddenly appear in urban centers to block roads, with texts like "Act now" and "Tell the truth." As such, XR successfully appropriates dystopian cultural tropes from popular film and television, turning them into symbols of protest and resistance. While in the *Mad Max* universe, similar imagery represents the near impossibility of survival in future extinction events, now extinction rebels refuse to go down quietly or wait for the worst to happen. "Survival is insufficient," reads one of their banners. What used to be the dystopian backdrop in the Hollywood market of end times now takes center stage, expressing both climate grief and fury over ecosystem loss. This dual reality—acknowledging the loss of extinction

Extinction Rebellion protest gathering around Joep van Lieshout's sculpture *Cascade* (2010), Rotterdam, April 20, 2019. Photo: Jonas Staal.

and rebelling against it simultaneously—is characteristic of the movement's practice of climate realism. XR wishes to be disillusioned, to act without illusions, with regard to worlds already lost.[18] It unites the extinct with those in extinction.

What happens when *Mad Max* backdrops refuse to silently embrace climate extinction is evident in the form of the theater group known as the Travelling Symphony in the TV miniseries *Station Eleven* (2021), based on the 2014 book of the same title written by Emily St. John Mandel. This queer troupe of actors, musicians, and acrobats performs eccentric interpretations of Shakespeare in a post-pandemic world, in which a hypermutable virus has killed more than 7 billion people across the world's population. Different from the familiar cinematic dystopian tropes in which near future societal collapse is the ground for warring factions, theft, rape, and murder, the series emphasizes the importance of the living worlds of those in extinction. The Travelling Symphony is an expanded chosen family, for whom art represents a deepening of bonds, a shared grief, rebellion, and joy. They show that the end of the world is never the end of *all worlds*. Friendship, love, rage, organizing—these become not less important during climate collapse, but even more essential for weaving structures of solidarity and meaningful survival. Although we need that joy and rage in the here and now—not in possible futures.

XR is no Travelling Symphony, especially because of its predominantly white, middle-class makeup, as has been critically voiced by the coalition of decolonial climate activists, Wretched of the Earth.[19] This is particularly evident in XR's strategic use of mass arrests as a way of gaining public traction and attention, which for Black activists and activists of color is far more dangerous due to systemic, racially motivated, police violence. White, middle-class rebels do not face the same institutional crackdown, and XR has a complicated track record when it comes to recognizing the racial and class components in the extinction war, for example, when it blocked the London tube, which, as a form of low-carbon public transport is not only the wrong target to protest, but also predominantly used by working-class people[20] Equally lacking is the dimension of climate realism

described by Stanley Robinson in the form of the Children of Kali: the willingness to go beyond "civil disobedience" and face the structural violence imposed by the fossil fuel industry and its state accomplices with legitimate acts of climate defense.

This is where the work of Andreas Malm comes in, who, together with artist Didem Pekün, has propagated an instructive poster series titled "How to Disarm SUVs." It follows a successful campaign by Malm and a wider collective in Sweden, for which small swarms of activists roamed upper-middle-class neighborhoods, deflating the tires of SUVs. The action gained quick traction—and was even taken up in other countries—as it builds on the general dislike of high-emission vehicles by wide segments of the general population, while using subversive humor to create popular acceptance that we must go beyond the means of legally sanctioned protests and move into the field of fossil fuel sabotage. The response to this relatively mild entry into extractivist property sabotage was met with fierce resistance: SUV owners roamed the neighborhoods, often armed, trying to catch those obstructing their vehicles.[21]

We encounter a cinematic equivalent of Malm and Pekün's campaign in Benedikt Erlingsson's film *Woman at War* (2018), in which the protagonist, Halla, employs contemporary guerrilla tactics to sabotage extractivist energy industries in Iceland and keep the government from signing a deal with China to open a new aluminum smelter. As she writes in her anonymous manifesto: "I urge everyone to rise up and use their ingenuity to cause damage to these enterprises. That's the only thing those psychopaths, those global multinationals, can understand."[22] Halla's actions focus on sabotaging energy supplies and include blowing up electricity transmission towers, while making sure to cause no harm to humans. Nonetheless, the corporate media portray her actions as inevitably leading to physical violence, demonstrating that in our era the disruption and sabotage of fossil fuel property is treated as equivalent to taking human lives. This then legitimates the state and corporate apparatus to hunt down climate activists as if they are terrorists of some kind. One example of many is climate activist Jessica Reznicek,

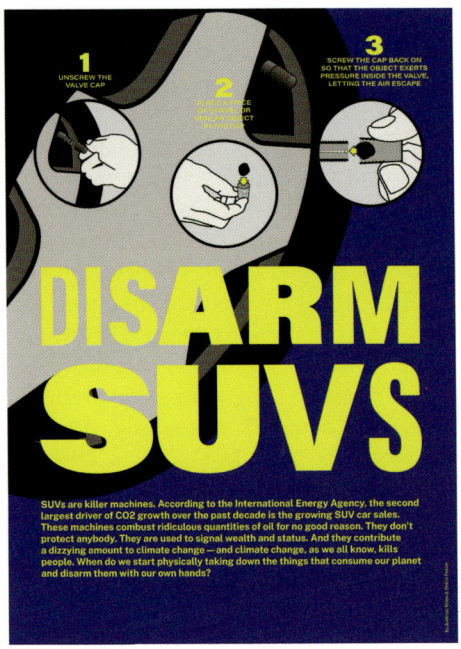

Andreas Malm and Didem Pekün, *Disarm SUVs* (2021).

who has been sentenced to eight years in federal prison for sabotaging the Dakota Access Pipeline.

This equivalence of property with life—or even property as something more valuable than the living—becomes exceptionally clear in the case of the *zone à défendre*, or ZAD, an autonomous rural community in Notre-Dame-des-Landes, France, which is spread over a 1650 hectares of land. The ZAD is both the name of a place, and the name of a collective of people living in that place, which emerged from decades of successful local struggles against the government's plan to build a new airport in the region that would evict farmers and cause major ecological destruction. The state's term to earmark the land for future infrastructure development was *zone à d'aménagement différé* ("deferred

development zone"): so apart from a reclaiming of the land, the ZAD is also a hack of the title given to the land by state actors.

The ZAD's unique history of community and resistance is narrated by, among others, Isabelle Fremeaux and Jay Jordan, founders of the Laboratory of Insurrectionary Imagination, or laboffi, a group of art-activists that emerged from an East London squatted social center in 2004 with the aim of bringing artists and activists together to "co-design tools of disobedience."[23] Having actively designed experiments with laboffi for many years in support of the alter-globalist movement and climate justice activism—direct actions with a performance-based and confrontational character—their frustration with the life cycle of short-term intensive activism that always forced them to return to the metropolis and its capitalist machinations encouraged them to desert the city. But where to desert to? In 2009, a collective founded by families in Notre-Dame-des-Landes known as *habitants qui résistent* (inhabitants who resist) published an open letter asking activists to not only temporarily protest the planned airport on their lands, but to squat the land and move into the empty homes of those who had been evicted. The Laboratory, inspired by the call, joined the struggle in 2012 and moved onto the land in 2016.

And thus, the ZAD emerged as a hybrid coalition of ecological activists, urban squatters, anarcho-primitivists, libertarian-communists, and eco-anarchists who joined local farmers from the region and inhabitants of the nearby towns and villages. Where the airport control tower was scheduled to be built, there is now a twenty-meter-tall lighthouse that emerges from the forest to "welcome the world to port."[24] The cyberpunk-turned-solarpunk piracy aesthetics of the autonomous ZAD patchwork goes beyond temporary halts to city traffic as they do in Extinction Rebellion; neither do they roam a post-pandemic world for Shakespearean relief as depicted in *Station Eleven*. The ZAD's lighthouse calls the rebels of the world to join to hold the ground in "deep presence," and to *become* the ground against one more extractive, polluting settlement on a world that can bear no more.[25]

But the story of the ZAD does not begin and end with a colorful patchwork of self-governing farmers and squatters. Its story, which has remained resilient until this very day, is shaped by high-risk climate defense struggles in the face of extinction wars. The infamous Opération César that began in 2012 sent thousands of police to evict those in the ZAD, to destroy the proof that living and resisting together is possible, and to clear the way to build the airport. But the ZAD had erected barricades, and thousands had gathered in support. At critical moments, people would come again and again. In 2016, at one of the peaks of the militarized threats of evictions, 40,000 people joined, converging from three different directions for a collective ritual, in which each brought a stick or staff to plunge deep into the earth and make a pledge to defend the land. In January 2018, the government canceled the planned construction of the airport; but as an act of revenge, three months later, the largest law enforcement operation since May 1968 was launched to clear the ZAD: thousands and thousands of gas canisters and stun grenades rained down for weeks and forty homes were bulldozed. Even then, a full-scale war needed to be waged to break the bonds of solidarity and popular support:

> There were also thousands of acts of solidarity that proved a lifeline: French consulate parking meters and barriers in Munich were sabotaged; musicians sent specially composed songs; banners were unfurled in front of French embassies in Delhi, Helsinki, New York, and Berlin and even underwater thanks to rebel scuba divers. Zapatistas sent their solidarity. An open letter penned by architects and signed by 50,000 appeared in *Le Monde*, the widely circulating French daily, deploring the destruction of the zad's unique forms of inhabiting. On the zone, three activist field kitchens came to feed us—the cooks wore gas masks while peeling vegetables.[26]

In the end, it was divide and rule tactics that proved the most effective tool of the French state—offering some the possibility

Banner showing solidarity for global struggles, at the ZAD's occupied road, Notre-Dame-des-Landes, 2017. Photo: Philippe Graton. Courtesy of Jay Jordan and Philippe Graton.

The Laboratory of Insurrectionary Imagination, *The Illegal Lighthouse against an Airport and Its World* (2016). Photo: Jay Jordan.

to stay legally but only on individual titles. And one could argue that the architect's public letter pleading to preserve the ZAD as cultural heritage—in a similar, ingenious way, Sandi Hilal and Alessandro Petti have called for the Palestinian Dheisheh Refugee Camp to be recognized as UNESCO World heritage[27]—was an attempt to hijack notions like "national culture" and use them to secure a space of counter-power instead. In the words of the Laboratory of Insurrectionary Imagination: "Commoning on the zad has taught us that to build a revolutionary force we must orchestrate all the dimensions of resistance (self-defense and disobedience), material means (places to meet, production of food, etc.) and affective work (through culture, songs, poems, etc.)."[28] To that list, we might have to add administrative hijacks as well.

Transformative climate propaganda that aims to propagate climate realism for disaster care and repair will not be sufficient without climate defense. As the Laboratory makes clear, becoming the storm to change its course means to face the brutal forces that unleashed it in the first place. For the ZAD, propagating new worlds means making and defending them, through new collective rituals and the very architectures that make up the autonomous zone. As such, they propagate not only an imaginary, but an imaginary in practice, a propagation in the form of an alternative life-form, a form of living. The ZAD's lighthouse is one of the rare, persistent lights that shows us a way home to a future transformed.

The Red Deal

Waseese, a young Cree woman, stands in the open field, not far from the forest tree line where a group of First Nation fighters are armed and ready to defend their community. In front of Waseese, in attack formation, stands a long line of heavily armed soldiers from the Southern Army in black protective gear. Above them, enormous swarms of fighter drones turn the blue sky black, emitting heavy buzzing sounds. Waseese looks up to

the drones, brings her arms into the air, and murmurs a Cree incantation. One drone breaks loose from the cloud, coming near her. At first seemingly threatening, and then, *listening*. And suddenly, the mechanical swarm breaks their strict formation, and begins to circle the sky like starlings, before attacking the soldiers instead. Overpowered, they scatter back to the urban centers of the occupying forces.

This is one of the closing scenes of the film *Night Raiders* (2021), directed by Cree-Métis film director Danis Goulet. It takes place in the year 2043, in the aftermath of a civil war in North America that sees the Southern Army of the United States intervene and integrate Canada into its territory. A large wall now fences off parts of the North from the South, forming an open-air prison reserve for undesirables in the northern territory, who are kept barely alive with occasional food drops. Children from the reserve are systematically confiscated by the state, sent off to residential schools to be "reeducated," and recruited into the far-right ultrareligious Southern Army. Waseese was one of these children in state custody, before being freed by the night raiders, an Indigenous resistance group and their allies who have been forced to defend their land past, present, and now *future*.

Goulet's dystopian narrative might sound familiar in the realm of postapocalyptic films, but this is in fact *her* story. Apocalyptic disaster films often present viewers with futures in which women's reproduction is controlled by the state, children are confiscated, and people are placed in camps or zones under extreme totalitarian rule. But while Hollywood has turned these into stories with predominantly white protagonists, this story, instead, belongs to the many Indigenous nations whose pasts are nearly indistinguishable from these futures.[29] In dystopian cinema, the crimes of the white colonists are projected and whitewashed as a future they themselves are to be fearful of. What they fear is their own violent inheritance.[30] The Indian residential school system of the nineteenth and twentieth centuries belongs to a lived colonial past, in which First Nations children were abducted from their families and obligated to

Waseese speaks to the drones of the occupying Southern Army in Danis Goulet (dir.), *Night Raiders* (2021). © Alcina Pictures–Eagle Vision.

unlearn their language, history, and traditions as part of a project of forced assimilation by the colonizers, often facing brutal physical and sexual abuse, if not murder. Many unmarked graves of Indigenous children are still being unearthed today.[31] Goulet makes clear that the apocalypse is not just a possible future: it is an Indigenous past that never truly ended, that continues through contemporary forms of state repression.

The band of Indigenous resistance in *Night Raiders* operates behind the wall in the region surrounding Weyakwin City, which is home to the Métis Nation. They are depicted as the rare peoples capable of maneuvering the future apocalypse, as they organize the escape of their children from the residential schools—as they did in the past—and live autonomously in the forested areas guided by elders, educating the young in the use of plants and hunting of animals. But the representation of their community and tradition is not technophobic. Among the night raiders are hackers who infiltrate the occupier's surveillance systems. Modern weaponry retrieved from the army is used for purposes of self-defense. This is also an essential component to the scene in which Waseese speaks to the drones: nature is a relation that does not exclude technology, but fosters caretaking and defense of the land, not its extraction and destruction.[32] As such, Waseese's resistance is a form of what Gerald Vizenor termed "survivance":

> Survivance is an active sense of presence, the continuance of native stories, not a mere reaction, or a survivable name. Native survivance stories are renunciations of dominance, tragedy, and victimry. Survivance means the right of succession or reversion of an estate, and in that sense, the estate of native survivancy.[33]

As Lower Brule Sioux Tribe citizen Nick Estes has written, "Our history is the future." That means that Indigenous apocalypses of the past, without a fundamental change in colonial and imperialist systems, will continue to haunt the present

and become unlivable futures for the many. It also means that inherited Indigenous practices of caretaking of the land and the earth workers who live in interdependency with the land should be the paradigm based on which a transformation of political, economic, and social systems take place. This is central to *The Red Deal* (2021), published by the Indigenous coalition the Red Nation—of which Estes is a member—as a response to various Green New Deal proposals. The Red Deal builds on the work of the Bolivian Movimiento al Socialismo (Movement toward Socialism) and its 2010 People's Agreement, which "spells out principles of ecofeminism, ecosocialism, and anti-imperialism infused with traditional Indigenous ecological knowledge."[34] Evo Morales, the first Indigenous Aymara president of Bolivia, has described the practice of these principles as a form of "Indigenous socialism" in which the caretaking and relationships harbored by First Nations are essentially recognized as a form of pre-socialist socialism: an understanding of ecology based on equality and interdependency, rather than the extractivist paradigm that industrialization—including industrial socialism—espoused.[35]

The Red Deal aims to build a broad coalition of Indigenous, Black, and leftist people and organizations, and is clear in its critique of the "green industry" paradigm underlying the Green New Deal: "In this era of catastrophic climate change, why is it easier for some to imagine the end of fossil fuels than settler colonialism? To imagine green economies, carbon-free wind and solar energy, and electric, bullet-train utopias but not the return of Indigenous lands?"[36] Ocasio-Cortez's alliance has come to recognize this fundamental question, as we saw in the case of *A Letter to the Future II*, but the real-time legislated versions of watered-down Green New Deals—such as the one passed by the European parliament—indeed does not mention a single word about land return or colonial reparations.[37] Climate catastrophe is thus disconnected from the system of colonial extraction that produced it in the first place. Even worse, the same system in a greenwashed form is expected to

provide the solution, rather than being recognized as an inherent part of the crisis.

Divestment is a key term in the Red Deal, particularly divestment from what Winona LaDuke of the Ojibwe Nation calls "Weitiko": the "cannibal economy."[38] In this understanding, confronting climate catastrophe and making repair possible would mean fully divesting from settler colonialism, divestment from the police and immigration and customs enforcement, divestment from the prison and military industrial complex, divestment from foreign occupation and imperial borders. This entails abolishing and dismantling the cannibal economy and the inherited colonial systems of violence and extraction that brought it into being, as the choice is between "decolonization or extinction."[39] In contrast to the necrosphere, the Red Deal proposes a "caretaking economy" centered on educators, healthcare workers, counselors, water protectors, and land defenders as "agents of life."[40] This caretaking economy would include citizenship for the undocumented, equal access to sustainable housing, free health care and education, public transportation, noncarceral mental health support, and sustainable food production.

So what constitutes the "red" in the Red Deal? On one hand, it refers to a derogatory term used to describe Indigenous and First Nation peoples, now reclaimed as a position of ancestral knowledge and resistance. On the other, it refers to the "red" in the history of socialist movements. Combining Indigenous and leftist heritage emphasizes presocialist socialist worldviews in which land, resources, or nonhuman animals were considered not property, but "nonhuman relatives"—comrades in the struggle for a biosphere for all.[41] Considering the world from a nonproprietary point of view is thus nothing new; it does not declare—as many socialist movements once thought—a fundamental break with history, but instead builds on forms of caretaking and collectivity central to certain Indigenous practices.

This nonproprietary paradigm of ecology is what the art and activist collective Not an Alternative describes as a form of "Red Natural History." Traditional natural history is deeply

complicit in the sixth mass extinction. Many animals and plants went extinct exactly because of their "discovery" by scientists traveling as part of colonial missions. Colonial science considers other living beings not as nonhuman relatives or fellow earth workers but as resources "discovered" for extraction. Colonial knowing thus equals annihilation. A Red Natural History, on the other hand, fundamentally rejects the separation between humans and nature: instead, one encounters another, because living beings were already known to themselves and their communities. Such an Indigenous understanding rejects the world as property, instead recognizing "a world in common."[42]

Not an Alternative's transformative climate propaganda takes shape through the project *The Natural History Museum* (2014–ongoing), essentially a campaign that manifests as a traveling museum. The collective organizes exhibits in existing natural history museums; initiates symposia and educational programs; partakes in Indigenous campaigns, protests, and direct actions; and travels with their own natural history bus covered with education-friendly animal cartoons. To the public, their hijacking of the visual language of existing natural history museums indeed makes them look like *the* natural history museum, rather than the Indigenous socialist agitprop campaigners that they are. As a result, they have been invited to join the American Alliance of Museums, infiltrating the dominant natural history paradigm with their Red Natural History.

The transformative dimension of Not an Alternative's propaganda work comes in two parts. First, they show how colonial extraction fundamentally alters ecosystems, for example, in the form of their own dioramas. Whereas naturalist dioramas (in the European tradition) typically take the form of glass vitrines in which taxidermied animals are placed in an idealized reconstruction of their "natural" environment, Not an Alternative's dioramas instead show stuffed polar bears surrounded by defunct tires, broken TV sets, and toxic water. Here, nature is shown transformed as part of a "fossil fuel ecosystem."[43] Not an Alternative's slogans, such as "Our climate, whose politics?" and "Will the story of the 6th mass extinction include its sponsors?,"

A totem pole–blessing ceremony led by members of the Lummi Nation at the opening of *Whale People: Protectors of the Sea*, an exhibition by the House of Tears Carvers of the Lummi Nation and *The Natural History Museum* at the Florida Museum of Natural History, Gainesville, Florida, 2018. Photo: Kristen B. Grace. Courtesy of Not An Alternative.

make clear that this fossil fuel ecosystem includes traditional natural history museums themselves, as they receive funding from fossil fuel giants such as Koch Industries, which benefit from maintaining a public conception of a pristine nature unaltered by their own ecocidal extraction.[44]

But Not an Alternative's *Natural History Museum* is not limited to making visible the changes of our ecosystem due to fossil fuel extraction. The other transformative dimension of their propaganda work relates to the liberation of Red Natural History that exists enclosed within traditional natural history museums. In the collective's words: "This other natural history was not annihilated, only obscured—symbolically imprisoned in museum vaults and display cases, where it remains as a specter that haunts natural history from within."[45] Their project *Whale People: Protectors of the Sea* (2018) is a good example. It spotlights the endangered orca, known in the language of the Indigenous Lummi Nation as "Qw'e lh'ol mechen," meaning "our people that live under the sea." This project involved bringing a whale totem, created by Lummi Nation carvers Jewell James and the House of Tears Carvers, into the Florida Museum of Natural History, after it had already traveled to various sites of climate struggle across the country. Turning the exhibition space into a site of collective ritual, elders of the Lummi nation guided visitors in laying hands on the totem, collectively evoking the specter of Red Natural History from within the museum, liberating social histories, practices, and nonproprietary life forms—collective forms of living—that are tied to its stolen objects.

The struggle between Red Natural History and natural history is the one described by the Red Nation as that between decolonization and extinction. For the former, "the world ... [is] not a resource to be extracted, but part of a system of reciprocal relations and obligations between humans and nonhumans that demand ... mutual respect, non-domination, and nonexploitation."[46] Transformative climate propaganda thus not only propagates a new behavioral response, a new mentality centered on disaster care and repair, but equally builds on and evokes inherited and ancestral practices and forms of life that lingered

in capitalist enclosure: a dialectic propagation of a world across future pasts and past futures.

Deep Transformation

A tall Black man in a black mask, bare from the waist up, with a green, yellow, and black Surinamese Maroon pangi cloth wrapped around his waist, stands on a group of large rocks on Ile de Ngor, Dakar, with his back turned to us. Waves crash onto the rocks around him, drenching his feet and legs in water and foam. While his face is turned toward the ocean, his pitch-black, ancient-looking mask with ear-like robotic antennae faces the viewer. On one side of him: the land, from which his ancestors were stolen and turned into commodities. On the other side: the ocean, on which ancestors were forcefully abducted to an old world declared "new."

The sea is a space of crime, an arena marked by violent patterns of forced migration of humans, animals, goods, and resources.[47] The colonial crime has equally proven to be a climate crime, as the ocean in front of the tall figure is heating up, its ecology mutated through microplastics and other poisons, its living and nonliving resources plundered for mass consumption. While the Black man's human face is directed to that toxic ocean history and present, his black mask faces the homeland: his birth site and the site of original sin of colonial extraction. At first glance, the mask seems ancient, but it has mutated, merged with technology. Its pitch-black surface is the future staring back at the viewer. The figure stands motionless at the shore for a long time, facing forward by face and backward by mask at the same time. Now he raises his arms slowly, evoking violent pasts, ecocidal presents, and Black futures, ritualizing a process of deep transformation.

This is a description of the video *Atlantic Transformerz: Ile de Ngor* (2014), by artist Charl Landvreugd. The "Transformerz" are characters that appear throughout his work to visualize the African diaspora on four continents, as agents that are shaped

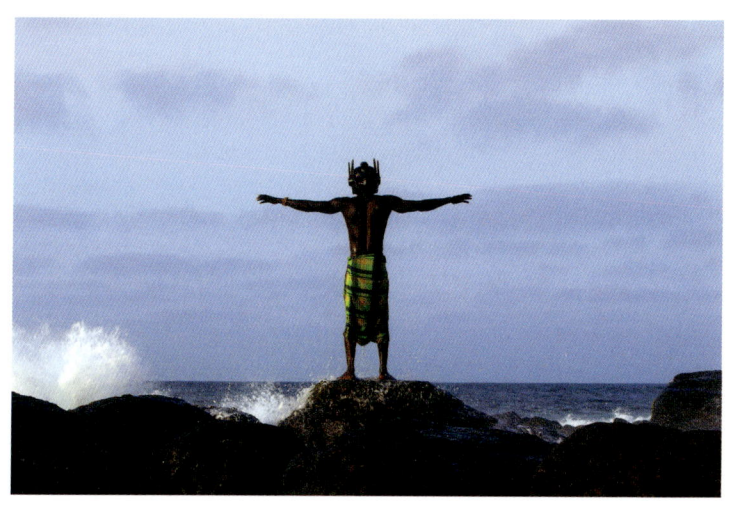

Charl Landvreugd, *Atlantic Transformerz: Ile de Ngor* (2014), video, 13:48, still. Courtesy of the artist.

by histories of violent theft and arrival. They propose an understanding of identity through hybridity. The African American, or the Afro-European in Landvreugd's case, originates both from ancestral land and colonial inheritance.[48] The Transformerz's Blackness equally embodies a world fractured by colonial violence as well as hybrid Afrofuturities in which the ancient and the modern coexist.[49] Landvreugd calls this the "utopia of the imagined normal space," a realm in which identities are understood as plural Indigeneity to different geographies, histories, and cultures.[50] Being Indigenous not just to a place but to a process of both violent theft and transformative resistance evokes a radical queerness that opposes reductive racial and nationalist notions of origin. Blackness in Landvreugd's propagations means to originate from various conflicting histories, geographies, and cultures at the same time. As artist and food activist Zayaan Khan would say, his is an art of "ancient futures" where one belongs to different pasts, presents, and futures at the same time.[51]

In the film *The Girl with All the Gifts* (2016), directed by Colm McCarthy based on the 2014 book by M. R. Carey, we encounter this paradigm of deep transformation in the form of a young Black girl named Melanie. She is held in a military compound in a near-future England to be studied, as she has been infected by a pandemic illness caused by a parasitic fungus that has ravaged society, leaving collapsed cities in its wake haunted by so-called hungries, zombie-like beings that crave living flesh. London's rocketship-shaped BT Tower operates as the zombies' rallying point, as it has been overtaken by fungal growth containing its seedpods. Dr. Caroline Caldwell is put in charge of studying Melanie and other infected children in search of a cure, to return them to their "original" state of being. But when Melanie manages to escape her human guards and set the tower on fire in order for the pods to break and the fungus to spread indefinitely, it becomes clear that she—a hyper-intelligent zombie-human hybrid—might not need to be "cured," but actually might *be* the cure for a transformed population seeding a regenerated fungus planet. While this means humanity as it is known will cease to exist, this narrative differs fundamentally from the

London's BT Tower is overtaken by fungal growth that will transform humanity in Colm McCarthy (dir.), *The Girl with All the Gifts* (2016), still. Moviestore Collection Ltd.

genocidal fantasies of ecofascist propaganda. Humanity is not annihilated, but transformed. The search for their supposed "cure" by Dr. Caldwell might have less to do with the idea of "saving humanity" and more to do with fighting her own fear of *not staying the same*.

There is a similar transformative propagation in Jeff VanderMeer's novel *Annihilation* (2014), the first book in his *Southern Reach* trilogy. Its main protagonist is not a human, but an expanding ecological zone known as Area X, located on the US coastline surrounded by a nearly impenetrable invisible border. The Southern Reach is the clandestine military and scientific agency charged with ensuring Area X does not grow any further, while trying to understand its origins. For this reason, the agency sends various missions through a specific part of the invisible wall that functions as its entry point, but its members vanish or return in an almost ghost-like form, plagued by amnesia and succumbing to cancerous mutations and suicide. The book follows four women who embark on the twelfth expedition into Area X, one of whom is described as the biologist whose husband had returned from Area X a phantom, before perishing.

Once in the area, the biologist comes to realize the haunting extent to which Area X's assimilative spore-exhuming ecosystem

is metamorphic. Plant samples prove to contain human cells, copied or adopted from humans previously venturing in the area. Objects left behind by members of previous missions have become included into the ecosystem—including a diary that continued to self-replicate and self-write, turning into an organism of its own. An underground "tower" seems to be breathing, its staircases littered with organic writing of ever-evolving, haunting poetry. A key node in Area X's metamorphic ecosystem is a being the biologist describes as the "crawler," a hybrid, light-filled body carrying a reminiscence of the face of the first person ever transformed by the metamorphic bionetwork. For Area X, ecology is not limited to cells, but includes writing and technology, thoughts and ideas. It radically rejects the idea of nature as an externality, as it constructs a new biosphere in which the separation between human, plant, diary, word, thought, and dream are eradicated—*annihilated*. As the biologist notes: "I melted into my surroundings, could not remain *separate from*, *apart from*, objectivity a foreign land to me."[52]

The human characters in *The Girl with All the Gifts* and *Annihilation* live in fear of being "infected." They consider transformation an undoing of their bodily sovereignty, an eradication of the comfort they take in considering themselves something else, autonomous from their environment: to be human, and not nature. But "infection" proves to be a reactionary term for transformation, a transformation away from these false conceptions of individuality, of independence and sovereignty from one's surroundings. Instead, transformative propaganda shows that we are not autopoietic—not self-creating—but rather *sympoietic*, meaning that organisms are always "making with" and being made by and through others, made by other humans, non-human animals, plants, thoughts, ideas, dreams, and desires.[53] Transformation proves closer to a terrifying truth of what we are as humans: not autonomous, but always haunted by a process of a possible becoming.

This possibility is fundamental for the transformative ritual work of MELT, formed by artist duo Ren Loren Britton and Iz Paehr.[54] Their *MELTING MANIFESTO* declares: "human

technologies and ongoing histories of colonial violence further the melting of polar ice caps and subsequent rising sea levels which are threatening to life on Earth."[55] Here, melting describes the change of the climate, the storm unleashed upon us through colonial extraction. But simultaneously the manifesto states: "Melting offers alternative assemblages of condensing, liquifying, and embracing dissolution," meaning that changing with the climate—becoming part of the storm to change its course—is a chance to undo, *to melt*, the mechanisms and ideologies that led to the disaster in the first place.[56] Melting then becomes, in their words, a transformative "en/counter practice": it recognizes the chance to change in sympoietic *encounter* with others, while it stands as a *counter* resistance to ecocide. A propagation of transformation, against extinction. Just as the biologist in Area X had noted: *I melted into my surroundings.*

To describe the necrosphere that ecofascist propaganda tries to make real and actionable, we were aided by the critical

Cosmic rays melt the binary code of computing boards, following the principles of the *MELTING MANIFESTO* in the work *Etching towards Non-Binary Computing* (2021) by MELT (Ren Loren Britton and Iz Paehr). Image description by MELT: "A PCB board with the word MELT etched onto it. Attached to it is a battery and a green LED. A white person's hand is holding the board as the sun peers through its edge."

perspective in Octavia Butler's diptych *Parable of the Sower* and *Parable of the Talents*, which describe the rise of Andrew Steele Jarret's Christian America Movement. But in their critique, the novels also represent a transformative counterpropaganda, in the form of protagonist Lauren Olamina. She is a hyper-empath, someone who feels the pain of others as if it were her own, and this makes her an embodiment of interdependency, of sympoiesis. Her only way to seek for meaningful survival in the impeding ecofascist apocalypse is one of collective flourishing and safety—self-interest and collective interest intimately intersect. For the pain of others is her pain; the joy of others is her joy. What first seems an affliction, a handicap, an infection, is in fact a chance to transform, both herself and others. So while Jarret propagates the necrosphere, Olamina begins to propagate her own biospheres in the form of so-called Earthseed communities: autonomous collectives organized for self-defense against the Christian American Movement's extermination campaigns, on one hand, and for collective care and repair of its communities, on the other.

And as Jarret's vengeful God shapes a necrosphere of ashes, Olamina reclaims God not as divine entity but as *change*. God is no longer a being, but a *practice* and a *process*: the transformative collective work of reseeding the Earth. A collective defined not by narrow religious doctrine, but as "construct" families: communities bound by regenerative purpose, not essentialist bloodlines.[57] Facing off with Jarret's apocalyptic necrosphere, the Earthseed communities resist and propagate, seed and harvest its spreading biosystems, until the Christian America Movement is no more. Opposite to the retro-nostalgic supremacist propaganda of ecofascism, is a new biostory: a new story of life.

As *Earthseed: The Books of the Living* propagates:

Consider: Whether you're a human being, an insect, a microbe, or a stone, this verse is true.

All that you touch
You Change.

All that you Change
Changes you.

The only lasting truth
Is Change.

God
Is Change.[58]

As evidenced here, the purpose of transformative climate propaganda is to turn biostories for living worlds and deep futures for all into reality.

Climate propaganda that calls for "deep adaptation" to the climate collapse, meaning to adapt the way we build our communities, transportation systems, and economies with the aim of extending survival, risks turning reactionary when unwilling to transform the conditions of being that led to the catastrophe in the first place.[59] Because transformative climate propaganda does not "adapt," but engages in a collective propagation to transform, to change with the climate, to become part of the storm unleashed by colonial extractivism and change its course to establish disaster care and repair. Deep transformation does not declare history dead for the new to arise; instead, it engages change across different temporalities, across different spheres of time and space, as we see embodied in the figure of drone-whisperer Waseese, and in the ancient-futuristic Transformerz. But whereas the retro-nationalist propaganda of ecofascism provides nostalgic comfort in the illusion of a return into time, deep transformation touches on our deepest fears: the fear of changing, transforming, mutating, metamorphizing, being altered. No longer having a home in the past, but being home in an unknown future where we can never be the same again.

*Afterword:
Biostories beyond Extinction*

Something really must go extinct, but it shouldn't be our ecosystem. What needs to be declared extinct is an extractive system, and the concomitant mentality it propagates. To change with the climate, to become part of the storm in order to change its course, means to let the death-form die. We do so by telling new biostories, and by turning these biostories into realities. To let living worlds propagate in thought and in practice. To harvest time seeds planted in the collective imaginary before us so that we could live, and to plant new time seeds for the future worldings of unborn humans, nonhuman animals, and plants. To "undrown" in a drowning world, as Alexis Pauline Gumbs phrased so powerfully.[1] To regenerate.

We are not the system. But those of us who were born into colonial, racialized, and extractive heritage, and who were taught to internalize these as "progress," will need to force some part of ourselves to go extinct, in order to mutate and melt, in

Jonas Staal, *Redistribute Extinction, Campaign Study* (2022), 50 × 75 cm, gouache on paper.

order to transform and propagate anew. This change of mentality requires opening time portals to a world beyond extinction. It requires the extinction of the necrospheres, resulting from the collective victory of our living worlds. The extinction of extinction.

It is thus a key question of who are the narrators of biostories, the stories of life. I'm no CEO of Amazon or ExxonMobil, but historically and at present, the power to narrate through imposition has always privileged white men in the Global North, like myself. That means that care and repair—rather than extraction and domination that have been part of the patriarchal mindset that enabled us to be the unquestioned narrators of history with a capital "H"—must be central to the changing of our mentality and being in and with the world. We face a collective struggle, in which dominant elites of fossil fuel capitalism form the minority opponent toward the majority of the living. But this macro-political struggle cannot go without our own micro-political divestment from the systems that distribute privilege not just to the trillionaire CEO, but to the dominance of white men in too many spheres of daily life. My aim in this writing has been to critically analyze dominant and extractive climate propagandas, but also to enact a practice of care and repair to biostories that enforce divestment from this extractivist mentality.

It's hard to imagine victory at a time that seems so full of defeat, as we witness rising authoritarianism, global precaritization, and ecosystem collapse. The sense that we face a future that will know no human history can lead to depoliticization and undermine the possibility of collective action. It can lead to climate nihilism: We're all lost, so why bother?

But it is exactly in the moment of deep structural crisis when egalitarian politics becomes even more important. Let's say that human worlds will indeed end. Even so, they will not end in a day. It follows the course of a horrifying multigenerational process of mass displacement, mass burning, mass drowning, and mass suffocation. Exactly in such a context, it is essential to fight for emancipatory governance that guarantees the equal distribution of the increasingly scarce food, water, and other

resources. This would be the equal distribution of extinction. The redistribution of extinction.

More importantly, though, there is something deeply arrogant in declaring the end of human worlds, when so many worlds have faced their own ends and resisted, as I tried to describe through the work of some of the Indigenous artists, cultural workers, activists, and organizers. It's an easy satisfaction, a form of perverse empowerment even, to declare oneself the last human, and refrain from intergenerational "response-ability," in the words of Donna Haraway.[2] Claiming our present world to be the last world also denies the friendship and comradeship, the intimacy, love, resistance, and the possibility of transformation that any human future—however compromised, however much under assault by extinction wars—will know. These have value, now and always, with or without worlds ending.

Worlds ended many times, resisted many times, regenerated many times.[3] This logic of beginnings and ends of worlds doesn't hold, except for those who benefit from considering themselves the holy arbiters of time over all and everything.

And to be disillusioned about the multifaceted crises of our times might not necessarily be a problem. With that, I don't mean to be defeatist, but to express my desire to undo myself from illusions: the illusion of growth, the illusion of stability, the illusion of progress, the illusion of individuality and sovereignty. These illusions are what need to go extinct in order not just to organize *against* extinction but to open the time portals to living worlds *beyond* extinction. The time seeds that I discussed in the context of transformative climate propaganda move across different temporalities. The biostories we plant, harvest, and propagate rely on those we have inherited. An inheritance from those disillusioned but determined to act without illusions, who came before us.

I recognize how much I am myself carried by the biostories that sprout from egalitarian time seeds, biostories that were propagated in both imagination and practice.

I think of the biostory told to me in an anonymous Chinese poster from 1959, in which for once it was not lyrical heroic

Fragment from a reworked propaganda poster from the Chinese People's Republic, artist unknown, 1959. Adjustments, Jonas Staal, 2019.

peasants and workers who took center stage to announce a new multiyear plan to increase the harvests, but the *crops themselves* that were painted as nonhuman proletarians: greens and wheats defiantly raising the red flag. The poster worked like a time seed: it planted the idea that if we take egalitarian politics to their outer consequence, it cannot be limited to humans alone but must recognize all nonhuman earth workers as comrades in the struggle for living worlds. That might not be the reality of Mao Zedong's policies at the time, but the poster operates as a time portal for others, in another time and place, to put its propagation into practice.[4]

I think of the biostories practiced by revolutionary Thomas Sankara, after he led the liberation of Burkina Faso in 1983. His transformative policies not only included the propagation of women into equal leadership positions, the propagation of mass literacy, country-wide vaccination, economic self-sustainability, free housing, free public transport, and the strengthening of Pan-African unity and cooperation against World Bank indebtment and neocolonialism. He also put into the ground the seeds for a new ecosocialist paradigm. His project to plant ten million trees to "make the Sahel green again" recognized that the transformation and regeneration of shared ecologies could not be directed by humans alone: comrade human and comrade tree needed to struggle side by side.[5] A biosphere for all must be erected and cared for through the collective efforts of all earth workers.

I think of the embodied biostories I listened to and witnessed when traveling with Amina in Rojava, the western part of Kurdistan in northern Syria. Amina came from "the mountains," which means she had been part of the guerrilla self-defense efforts against ongoing Turkish aggressions that have aimed to erase the existence of the Kurds throughout decades: an extended genocide against the largest nation without a state. But Amina no longer wanted a state. Instead, she resisted for autonomy, for the right to self-determine a form of life separated from the state, a "democracy without the state," as she phrased it following the Kurdish leader Abdullah Öcalan.[6]

In their long struggle for autonomy, the Kurds famously say that they have no friends but the mountains. The mountains provide nurture, but also shelter. The Turkish army, the second largest in the NATO alliance, has not been able to take control of the Kurdish territory for decades, despite increasing technological capabilities, compared with the now ancient-looking AK-47s of the resistance. But those who live and know their land are also defended by that land. The mountain is a friend, a comrade, a fellow guerrilla. And whenever I was walking with Amina, she was speaking to the mountain, picking fruits and grains that she shared with me. She cares for the mountain, her home, just as her home, the mountain, cares for her.

I think of the biostories that we inherit across deep pasts, like that of the Ediacaran, that stretched from 635 to 541 million years ago. The word "Ediacara" derives from an Aboriginal term for the Ediacara Hills in South Australia, home of the Adnyamathanha people of the Northern Flinders Ranges, which describes either a place of no water or the presence of hidden water.[7] And this is fitting for the hidden nature of the Ediacaran in Earth history, which was recognized as a geological era of its own only in 2004.[8]

For a long time, the so-called Cambrian explosion was credited with the emergence of complex forms of life, driven by the emergence of predatory species, which birthed the neo-Darwinian fantasy that evolution can result only from a dog-eat-dog logic where the winner—the predator—takes all. But the Ediacaran changed this georevisionism: their complex biota, neither plants nor animals, lived in a cooperative ecology for 94 million years, without any signs of carnivorous behaviors between them. Its sometimes described as the "Garden of Ediacara," like a Garden of Eden, but that risks turning this collectivist ecosystem into something metaphysical, which it was not.[9] Rather, the Ediacarans, which resembled circular disks, worm-like shapes, and elegant plant-like forms, prove that we originate not simply from competition and extractive behaviors, as capitalism likes us to believe. We originate just as much from the propagation of cooperation, collective work, and ecosystem revolt.

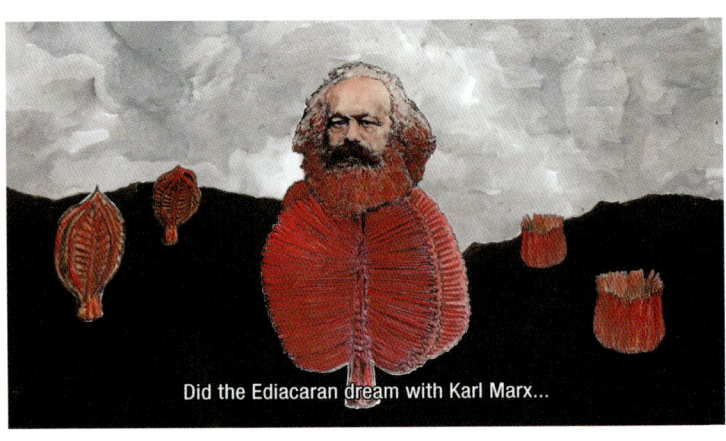

Karl Marx emerges from the Ediacaran biota Swartpuntia, flanked by Rangea (left) and Ernietta (right), in Jonas Staal, *94 Million Years of Collectivism*, video study (2022), video, 13:14, still.

We might even share the same dream, from 635 million years ago to the recent present, in the way that the Aboriginal people speak of the Dreaming, as a nonlinear space where ancestors and descendants coexist across space and time. This is how Aboriginal artist Doreen Reid Nakamarra addresses the Dreaming in relationship to artistic practice:

> In so far as the Dreaming has an ontological status, I argue that it cannot be comprehended outside of the acts which constitute it. ... works which are *about* the Dreaming literally bring the Dreaming *into being*. Ancestral potency arises within these paintings and is actively produced by them.[10]

When the Chinese artist paints the proletarian plants, or when Thomas Sankara made the Sahel green again, or Amina practices her comradeship with the mountain, they do so in resonance with the Ediacaran biostory: the possibility to live life differently, to share it differently, to become the storm we have been waiting for, the storm we have been dreaming about. The storm that has been dreaming us.

I am myself a propaganda researcher, but, in the tradition of emancipatory propaganda art, I also aspire to be a propaganda artist. To contribute to the propagation of time seeds and their biostories, both ancient and futuristic, that enable the transformation of living worlds beyond extinction. To resist dominant propagandas, we need propaganda literacy, and I hope this writing contributes to making visible the competing climate propagandas responsible for the undoing of the many worlds that inhabit our world. But more importantly I hope that the narration of transformative climate propaganda and its biostories acknowledges you as part of the storm to change its course, so that we can meet next time in the deep futures we will have collectively propagated.

Acknowledgments

I want to thank Victoria Hindley of the MIT Press for her support of our second book project, as well as managing editor Judy Feldmann, and Andreas Petrossiants, who intensively proofread my manuscript, as well as Isabelle Sully, who helped me prepare the initial concept. I further want to thank BAK, basis voor actuele kunst, Utrecht, especially Maria Hlavajova and Wietske Maas, for joining as co-funder to the project and developing a new organizational platform with me for the further propagation of its ideas: BAK is and will always be my base. Thank you also to Veerle Driessen, who assisted me in the image research for this publication.

As always, I want to thank the editorial team of *e-flux Journal*, who published my essay "Climate Propagandas" in 2020 and subsequent writings, which became the basis for a video study and this book. Other critical contributions have come from my long-term collaboration with writer, activist, and lawyer Radha D'Souza on our *Court for Intergenerational Climate Crimes* (CICC): there is no doubt I would not have been able to write this book without our intensive shared work following from her book *What's Wrong with Rights?* (2018), our ongoing conversations, and deep friend- and comradeship.

And this appreciation is extended to the institutions and people who helped Radha and my own transformative climate propagandas of the CICC to come into being: Framer Framed in Amsterdam, specifically Josien Pieterse, Cas Bool, Ashley Maum, Jiyoung Kim, Ebissé Wakjira, and Jean Medina; as well as the Van Abbemuseum, Charles Esche and Steven ten Thije in particular; the Helsinki Festival; the Gwangju Biennale Foundation and the Gwangju Art Museum; and Lucia Pietroiusti of General Ecology (Serpentine Galleries).

A special institutional and comradely thank you to post documenta: contemporary arts as territorial agencies as well as to Jonas Stuck Caroline Ektander, Antonia Alampi, Zayaan Khan, and the team of SAVVY Contemporary—The Laboratory of Form-Ideas, Berlin, that provided fertile ground for the propagations that led to this book.

Thank you to Jeanne van Heeswijk and our community at the Propaganda Social Club. And of course, thank you to the close friends, colleagues, and comrades with whom I was able to discuss the book and work on its themes across many deep conversations and collaborations, and sharpen it along the way, among which:

Stephanie Bailey; James Bridle; Beka Economopoulos, Steve Lyons and Jason Jones (Not an Alternative); Vincent W. J. van Gerven Oei; Nadine Gouders; Micha Hamel; Martin Guinard; Hans van Houwelingen; Marc Herbst; Jay Jordan; Paul Kuipers; Charl Landvreugd; Mihnea Mircan; Konstantinos Pittas; Laure Prouvost; Laura Raicovich; Filipa Ramos; Gene Ray; Adwait Singh.

Thank you to all the artists, cultural workers, and activists for sharing their work and images so generously with me. I know the work and dedication that goes into each, and I thank you for trusting me to care for them as best as I can.

Antonis Pittas and Remco Mol, at your house I wrote an important part of this book; thank you for being family.

And beyond gratitude are iLiana and Roxani: my gifts of life. Your deep love makes deep futures imaginable and actionable.

Climate Propaganda Models: Summary

I introduced five different models of climate propagandas. These models are not absolute. Sometimes they overlap. Sometimes one can work as a gateway propaganda to another. Sometimes we can recognize multiple propaganda narratives culminating within a single propaganda. My aim has been to dissect the master narratives and cultural imaginaries central to each, but that does not mean we could not articulate other models, or that these models are "complete." Nonetheless, I hope they work as a map of the climate propaganda struggle today, in order to recognize one narrative from another, to be able to position ourselves, to resist, and to propagate differently.

*

Liberal climate propaganda is propagated by the liberal corporate establishment, through fossil fuel–backed politics and the paradigm of "green" capitalism. It manifests through a culture of anthropomorphized nature documentaries, televised and cinematic climate metaphor, fossil-fueled philanthropy, and climate-splaining celebrities. It works to shape a worldview that is structured on a fundamental divide between humans and nature.

This separation leads to a dual consciousness, in which humans feel both in awe of nature and its devastation, and simultaneously superior to it. Climate catastrophe is subsequently narrated as the result of the behaviors of a generic "we"—humanity—a collection of human individuals, each of which has to take personal responsibility for planetary crisis. Green capitalism is the economy that builds on this hyper-individuated world view, but it cannot solve fundamental underlying experiences of climate grief and climate loneliness experienced by the liberal consumer class. In popular culture, this manifests in climate metaphors, in which a collapsing ecology becomes an allegorical backdrop for the personal emotions of individuals in the Global North. This continuous prioritization of the individual also shows the limits to which climate grief extends: while the liberal consumer class wishes to do "good," it has also been trained in a doctrine that can only consider individual (white) life as genuinely important. This is where the climate savior complex

comes in, which, rather than confronting the systemic and collective nature of crisis, deals in philanthropy and climate-splaining, reasserting enlightened superiority over nature and the Global South at large.

Through liberal climate propaganda, it is impossible to see the climate crisis as a systemic crisis or conceptualize a collective response. It propagates *every extinction for itself*, although it makes equally clear that some extinctions matter more than others. Its narrative of enlightened benevolence might trick one into thinking preservation of "nature" is its goal, but the only preservation that matters here is that of the liberal consumer class and its established power and privilege.

*

Libertarian climate propaganda is propagated by (right-wing) libertarian elites, through geoengineering corporations, space colonization outfits, and parallel financial systems. It manifests through a culture of libertarian science fiction to product-place its desired futures in the form of floating cities and Martian colonies, financed through catastrophe bonds and crypto mining, with the aim to extract living worlds and establish autonomous spheres of its own under techno-feudalist control.

To achieve this objective, libertarians approach extinction as a form of market expansion rife for speculation. They aim to deepen ecosystem collapse by undermining existing governmental institutions and cultivating overconsumption. Cryptocurrencies are a key example, as they do both: they destabilize dominant monetary institutions and aggressively overconsume energy to generate scarcity and thus open new market opportunities. This is libertarian propaganda's extinction loop: ecosystem collapse means broadening markets, and broadening markets means furthering ecosystem collapse. Extinction design is an essential component in this process, to product-place geoengineered futures on the scorched earth or in outer space as if they will become collective destinies for humanity, rather than the exclusive luxury bunkers of the designated surviving Earth elites. As such, libertarian climate propaganda is driven by a violent optimism: its exclusive futures are presented as a shared horizon, in order to gain acceptance from governments and populations to partake in their own ecocide.

Libertarian climate propaganda sees the systemic nature of climate crisis not as a problem but as a precondition—even an objective—to establish their monopolies on the ruins of our ecosystem. The notion of collective response to climate crisis in libertarian climate propaganda is unfathomable and undesirable, as its Ayn Rand–styled phantasms fundamentally reject collective interest as oppression of the sovereign, individual creative genius: the CEO or tech entrepreneur. Ecocide is mandatory to coin *extinction as currency*, and for libertarian elites to control all that remains in their new world.

*

Conspiracist climate propaganda is propagated by conspiracist networks and organizations, such as flat Earth societies, antivaxxer movements, and climate hoax activists. It manifests through a culture of viral videos and hashtags, flat Earth anti-globes, fossil-fueled shadow institutions such as the NIPCC and Anti-Gretas, the wellness-industrial complex, and para-sciences declaring the Great Reset in order to establish an alternative ecology of their own: an alt-world.

In conspiracist climate propaganda, several conspiracy narratives interlink, such as the antivaxxer movement and QAnon, as they identify the climate crisis as a "climate lockdown": an attempt to entrench globalist control over the world population. This coalition of conspiracist groups is serviced by the wellness-industrial complex, a manifestation of conspirituality that provides an economic and resource base with which to build the alt-world. It also allows for upper-middle-class wellness consumers to be recruited into the more extremist subculture of preppers working to fight the Great Reset. The culture of wellness is a response to careless and violent public institutions that leave populations to fend for themselves in navigating an increasingly precarious, austerity-ridden world of climate catastrophe with little means of subsistence, care, or reproduction, while criminalizing collective forms of survival. The "wellness" of the individual becomes an economic necessity, on one hand, and the last vestige of sovereignty, on the other. Faced with actual conspiracies that are out in the open, such as fossil-fuel lobbyism or the military-industrial complex's impact on the climate crisis, but lacking collective tools to confront them, conspiracist climate propaganda

offers a spiritual story in which the point is less about being able to change the world, and more about being one of the few who sees it for what it "really is."

Through conspiracist climate propaganda, it is impossible to see the climate collapse as anything other than an *extinction hoax*, a misinformation tool used by the globalist elites to expand their mechanisms of domination and control. When conspiracists call upon the public to join their cause, this is not to organize a collective response to actual existential threats, but an armed takeover to turn an escape to the alt-world into its actual realization.

*

Ecofascist climate propaganda is propagated by authoritarian leaders, racist and antisemitic political organizations, and their media networks. It manifests through a culture of genocidal fetishism, extinction role play, great replacement theory manifestoes, and blockbuster disaster cinema, aimed to normalize the massacre of large parts of the population and establish highly centralized and racialized authoritarian control over the remaining necrosphere.

A core narrative driving ecofascist climate propaganda is the overpopulation myth, in which slogans such as "humans are the virus" are used to dehumanize the planned targets of genocide. Racializing the climate crisis—for example, by identifying racial or religious groups as a threat to the body politic and claiming their excess reproductive activities will overpower white majority rule and their privileged access to resources—enables ecofascist climate propaganda to declare who have the racial right to survive and who do not. Ecofascist climate propaganda thus aims to fight extinction with ethnic cleansing. Through its use of disaster culture, ecofascists mentally and behaviorally train the populace in accepting the necessity of centralized rule and mass securitization to legitimize their pathway to power. The extinction sublime forms a critical component in shaping the ecofascist mindset, by propagating fascist joy as power and agency derived from imposing violence on people and the environment at large. It turns extinction into an aesthetic experience, imposed from the control rooms of the Global North upon the Global South.

In ecofascist climate propaganda, climate crisis provides an opportunity to impose its desired racialized order as *extinction*

supremacy. Ecofascists consider any collectivized response to the catastrophe a fundamental threat to their desired model of centralized securitization and genocidal management. The ecofascists instead gain support by promising a "return" to a natural world of order and balance, in which a superior racial class lives in abundance, but this retro science fiction proves fundamentally false. As critical climate fiction makes clear, the ecofascist necrosphere is a death form dictated by genocidal rule.

*

Transformative climate propaganda is propagated by emancipatory political organizations, Indigenous peoples and social movements, autonomists and Afrofuturists, queer organizers and biostorytellers. It manifests through a culture of Green New Deal time portals and Red Deal divestment, through urban swarms and lighthouses of the future, red natural histories and emancipatory climate fictions, with the aim of changing with the climate to enable deep transformation of political, economic, social, and cultural life-forms.

The aim of transformative climate propaganda is not climate adaptation, but climate transformation: a chance to fundamentally regenerate our worlds by divesting from the cannibalistic economy. Its narratives are guided by climate realism: a recognition of the devastating realities of the sixth mass extinction, on one hand, and a propagation of the realities that could become possible through disaster care and repair, on the other. But bringing climate realism into practice behaviorally comes with the price of facing the full militarized violence of the state and corporate forces that benefit from the extractive economy, which is why transformative climate propaganda emphasizes the importance of climate defense: the necessity to swarm and sabotage the system to block its operations, while creating autonomous alternatives from where to set up the front lines against the extinction wars waged against us. Transformative climate propaganda's objective for disaster care and repair builds on inheritances of Indigenous socialism before socialism, in which the division between humans and nature is rejected based on the paradigm of a world in common. Propagating this reality of interdependent human and nonhuman ecosystem workers into being means overcoming a fundamental fear cultivated by the illusion that humans are autonomous and

sovereign, rather than interdependent and in continuous process of collective becoming.

For transformative propaganda, the climate crisis embodies an existential urgency to change with the climate, to become part of the storm, and alter its course. Collective response for disaster care and repair is the only viable trajectory, no matter whether you're a human being, an insect, a microbe, or a stone. Only by recognizing kin- and comradeship across human and nonhuman ancestors and descendants can earth workers unite in a common front to face extinction wars as agents of life. These types of propagandas help us imagine deep transformations of our political, economic, social, and cultural systems, as well as the embrace of melting and mutating to overcome the fear of deep change, to propagate living worlds *against extinction*.

Notes

Introduction

1. Quoted from the Facebook announcement for "The CyberCunt Mini Ball by Father Chraja Kareola," which took place on October 5, 2019.

2. Samuel T. Turvey, ed., *Holocene Extinctions* (Oxford: Oxford University Press, 2009).

3. A term popularized by Elizabeth Kolbert, *The Sixth Extinction: An Unnatural History* (New York: Henry Holt, 2014).

4. See Harald Welzer, *Climate Wars: What People Will Be Killed For in the 21st Century* (Cambridge: Polity Press, 2012); Neta C. Crawford, *The Pentagon, Climate Change, and War: Charting the Rise and Fall of U.S. Military Emissions* (Cambridge, MA: MIT Press, 2022).

5. Radha D'Souza and my definition of extinction wars is as following: "Capitalism and colonialism are possible only by waging military campaigns against natures and peoples in the past, present and future. The annihilation of these living worlds of human, animal, and plant communities over the past 500 years constitutes *extinction wars*." From the exhibition text to Radha D'Souza and Jonas Staal, *Court for Intergenerational Climate Crimes: Extinction Wars* (2023), Gwangju Museum of Art, Gwangju. See further: Radha D'Souza and Jonas Staal (ed.), *Court for Intergenerational Climate Crimes* (Amsterdam: Framer Framed, 2024).

6. Sheena Wilson, Adam Carlson, and Imre Szeman (eds.), *Petrocultures: Oil, Politics, Culture* (Montreal: McGill-Queen's University Press, 2017).

7. Cited from Adwait Singh's curatorial text for "Vanishing Act," an edition of the Queer Arts Festival at the International Centre for Contemporary Asian Art, Vancouver, June 18–July 8, 2021.

8. Stacy Alaimo, *Bodily Natures: Science, Environment, and the Material Self* (Bloomington: Indiana University Press, 2010), 105.

9. Myra J. Hird, "Naturally Queer," *Feminist Theory* 5, no. 1 (2004): 85–89, 88.

10. Jennifer D. Roberts, Katherine L. Dickinson, Marccus D. Hendricks, et al., "'I Can't Breathe': Examining the Legacy of American Racism on Determinants of Health and the Ongoing Pursuit of Environmental Justice," *Ethics and Environmental Justice* 9 (March 4, 2022): 211–227.

11. Françoise Vergès, "Racial Capitalocene," in *Futures of Black Radicalism*, ed. Gaye Theresa Johnson and Alex Lubin (London: Verso, 2017), 72–82, 80.

12. See, for example, the chapter "The Golden Age of Environmental Law," in Naomi Klein, *This Changes Everything: Capitalism vs. the Climate* (London: Allen Lane, 2014), 201–204.

13. See Christophe Bonneuil and Jean-Baptiste Fressoz, *The Shock of the Anthropocene* (London: Verso, 2016).

14. See Radha D'Souza, Jonas Staal, Sharon H. Venne, et al., "Introduction to the Court for Intergenerational Climate Crimes (CICC)," *Errant Journal*, no. 2 (Spring/Summer 2021): 44–83.

15. See Radha D'Souza and Jonas Staal, *Comrades in Extinction* (Amsterdam: Framer Framed, 2021).

16. T. J. Demos not only critically deconstructs the Anthropocene, but also elaborates on its various counter narratives, such as the Capitalocene, the Chthulucene, the Gynecene, and the Plantationocene. See T. J. Demos, *Against the Anthropocene: Visual Culture and Environment Today* (Berlin: Sternberg Press, 2017). He also discusses the notion of the

"Pyrocene" as "the geological age of fire" in T. J. Demos, "The Agency of Fire: Burning Aesthetics," *e-flux Journal*, no. 98 (February 2019).

17. The concept of the Capitalocene is elaborated in Jason W. Moore, "The Rise of Cheap Nature," in *Anthropocene or Capitalocene: Nature, History and the Crisis of Capitalism*, ed. Jason W. Moore (Oakland: PM Press, 2016), 78–115. The notion of the "Racial Capitalocene" is elaborated in Vergès, "Racial Capitalocene."

18. Dorceta Taylor, *Toxic Communities: Environmental Racism, Industrial Pollution, and Residential Mobility* (New York: NYU Press, 2014).

19. T. J. Demos, *Radical Futurisms: Ecologies of Collapse, Chronopolitics, and Justice-to-Come* (London: Sternberg Press, 2023), 104.

20. This is a reference the Zapatista Movement for National Liberation (EZLN)'s description of their struggle as one for a "world in which many worlds fit." See EZLN, *Zapatista Encuentro: Documents from the First Intercontinental Encounter for Humanity and against Neoliberalism* (New York: Seven Stories Press, 1998), 29–30.

21. Andrés Jaque, Marina Otero Verzier, and Lucia Pietroiusti (eds.), *More-Than-Human* (London: Serpentine Galleries; Rotterdam: Het Nieuwe Instituut; Amsterdam: Manifesta Foundation; Madrid: Office for Political Innovation, 2020), 6. The term also references *More Than Human*, a 1953 science fiction novel by American writer Theodore Sturgeon.

22. Jaque et al., *More-Than-Human*.

23. On nonhuman comradeship, see Christina Kiaer, *Imagine No Possessions: The Socialist Objects of Russian Constructivism* (Cambridge, MA: MIT Press, 2005); Jodi Dean, *Comrade: An Essay on Political Belonging* (London: Verso, 2019); Oxana Timofeeva, *Solar Politics* (Cambridge: Polity Press, 2022).

24. Cited from Radha D'Souza and Jonas Staal, *Court for Intergenerational Climate Crimes*, video (2021), 12:32.

25. See Tarek A. Kassim and Damià Barceló (eds.), *Environmental Consequences of War and Aftermath* (Berlin: Springer, 2009).

26. Moore, "The Rise of Cheap Nature," 113.

27. D'Souza and Staal (eds.), *Court for Intergenerational Climate Crimes*, 35–43.

28. Radha D'Souza, *What's Wrong with Rights? Social Movements, Law and Liberal Imaginations* (London: Pluto Press, 2018).

29. Amitav Ghosh, *The Nutmeg's Curse: Parables for a Planet in Crisis* (London: John Murray, 2021), 82.

30. Paraphrasing Bruno Latour, Martin Guinard, and Eva Lin's exhibition title for the 2020 Taipei Biennale "You and I Don't Live on the Same Planet." See Martin Guinard, Eva Lin, and Bruno Latour, "Coping with Planetary Wars," *e-flux Journal*, no. 114 (December 2020).

31. A reference to Noam Chomsky and Edward S. Herman, *Manufacturing Consent* (New York: Pantheon Books, 1988), which identifies a propaganda model based on five filters through which US imperialist propaganda, and specifically the role of the mass media, functions. Chomsky and Herman borrowed the notion of manufacturing consent from Walter Lippman's *Public Opinion* (1922).

32. The section title "How Propaganda Works" is a reference to Jason Stanley's book title *How Propaganda Works* (Princeton: Princeton University Press, 2015).

33. I borrow the notion of the "master narrative" from Terence McSweeney, *The "War on Terror"*

and *American Film: 9/11 Frames per Second* (Edinburgh: Edinburgh University Press, 2016), 10.

34. This relates back to Chomsky and Herman's propaganda model, which specifically aims at assessing the "performance" of propaganda.

35. The role of performance in propaganda studies is extensive and is addressed by, among others, Tilman Allert, *The Hitler Salute: On the Meaning of a Gesture* (New York: Picador, 2005); Stephen S. Eisenman, *The Abu Ghraib Effect* (London: Reaktion Books, 2007); Joseph Masco, *The Theater of Operations* (Durham, NC: Duke University Press, 2014); and Marshall Soules, *Media, Persuasion and Propaganda* (Edinburgh: Edinburgh University Press, 2015. In my own propaganda research, I expand on these works specifically through Judith Butler's performance theory. See Judith Butler, *Notes towards a Performative Theory of Assembly* (Cambridge, MA: Harvard University Press, 2015), and Jonas Staal, "Assemblism," *e-flux Journal*, no. 80 (March 2017).

36. For a critical assessment of the post-truth concept, see Stamatis Poulakidakos, Anastasia Veneti, and Christos Fangonikolopoulos, "Post-Truth, Propaganda and the Transformation of the Spiral of Silence," *International Journal of Media & Cultural Politics* 14, no. 3 (2018): 367–382.

37. I elaborate further in Jonas Staal, *Propaganda Art in the 21st Century* (Cambridge, MA: MIT Press, 2019).

38. The idea that propaganda should be understood in the plural is taken from Jacques Ellul, *Propaganda: The Formation of Men's Attitudes* (New York: Vintage Books, 1973).

39. *Merriam-Webster*, "propaganda (n.)," accessed September 6, 2023.

40. Erwin W. Fellows, "Propaganda: History of a Word," *American Speech* 34, no. 3 (October 1959): 182.

41. Ibid.

42. Philip M. Taylor, *British Propaganda in the Twentieth Century: Selling Democracy* (Edinburgh: Edinburgh University Press, 1999).

43. Ibid., 187–188.

44. Jonathan Auerbach and Russ Castronovo (eds.), *The Oxford Handbook of Propaganda Studies* (New York: Oxford University Press, 2013), 5.

45. Upton Sinclair, *MammonArt* (San Diego: Simon Publications, 2003), 386.

46. W. E. B. Du Bois, "Criteria of Negro Art," in *Harlem Renaissance Reader*, ed. David Levering Lewis (London: Penguin Books, 1995), 100–105.

47. Transcribed from a lecture by Donna Haraway, Stedelijk Museum Amsterdam, March 25, 2017.

48. Lucy Lippard, *To the Third Power: Feminism, Art, and Class Consciousness* (New York: Dutton, 1984), 117.

49. Where the term "morphology" today has significance in domains as diverse as linguistics, biology, and mathematics, Johann Wolfgang von Goethe is considered to have defined the term in relation to the study of plants, explaining it as "the science of form [*Gestalt*], formation [*Bildung*], and transformation [*Umbildung*] of organic bodies." See Johannes Grave, "Ideal and History: Johann Wolfgang Goethe's Collection of Prints and Drawings," *Artibus et Historiae* 27, no. 53 (2006): 183.

50. W. J. T. Mitchell, *Picture Theory* (Chicago: University of Chicago Press, 1994).

51. Nicholas Mirzoeff, *An Introduction to Visual Culture* (London: Routledge, 1999), 5.

52. Marita Sturken and Lisa Cartwright, *Practices of Looking: An Introduction to Visual Culture* (New York: Oxford University Press, 2001), 379.

53. See Cine Móvil, "Don't Look Up—A Critical Analysis by Cine Móvil NYC," *Medium*, January 7, 2022.

54. For Stamatis Poulakidakos and Antonis Armenakis, the notion of scale takes yet another meaning in terms of various—sometimes simultaneous—propaganda methods, such as "sentimental methods" and "logical methods," which together form what they call the "total propaganda scale." Stamatis Poulakidakos and Antonis Armenakis, "Propaganda in Greek Public Discourse: Propaganda Scales in the Presentation of the Greek MoU-Bailout Agreement of 20103," *RSP*, no. 41 (2014): 126–140, 130.

55. Lippard, *To the Third Power*, 115.

56. Ibid., 116.

57. An approach exemplified in the field of geoengineering, discussed in chapter 2.

58. Lippard, *To the Third Power*, 117.

59. Ibid., 115.

60. Walter D. Mignolo and Catherine E. Walsh, *On Decoloniality: Concepts Analytics Praxis* (Durham, NC: Duke University Press, 2018), 17.

61. The notion of "becoming the storm" returns in various recent writers, among others Kathryn Yusoff, *A Billion Black Anthropocenes or None* (Minneapolis: University of Minnesota Press, 2018); Andreas Malm, *The Progress of This Storm: Nature and Society in a Warming World* (New York: Verso, 2018); and Steve Lyons and Jason Jones, "Towards a Theory of Red Natural History," *Society & Space*, May 11, 2022.

Chapter 1

1. See Sophie Lewis, "My Octopus Girlfriend," *n+1*, no. 39 (Winter 2021).

2. On the exploration of egalitarian approaches to other intelligences, see James Bridle, *Ways of Being: Beyond Human Intelligence* (Dublin: Penguin Random House Ireland, 2022).

3. Cited from Pippa Ehrlich and James Reed (dirs.), *My Octopus Teacher* (2020).

4. Referencing the poem "The White Man's Burden" (1899) by Rudyard Kipling, which called for the United States to colonize the Philippines and placed this in the context of the historical civilizational mission of a "superior" white race. David Graeber and David Wengrow's latest historical study argues that it was the supposed ahistorical "noble savage" that was the actual intellectual force that shaped European Enlightenment. See David Graeber and David Wengrow, *The Dawn of Everything: A New History of Humanity* (New York: Farrar, Straus and Giroux, 2021).

5. What Radha D'Souza describes as "land as relationship." D'Souza, *What's Wrong with Rights?*, 5.

6. On the intersection of Western colonialism and climate crisis, see Ghosh, *The Nutmeg's Curse*.

7. The lowering of information in documentaries and their increased visuality is also a product of the cinematification of the documentary form; see Brett Story, "How Does It End? Story and the Property Form," *World Records Journal* 5 (2021): 81–90.

8. See further Jerrine Tan, "Watching 'A Life on Our Planet,' or How I Ruined David Attenborough for Myself," *LA Review of Books*, May 23, 2021.

9. The environmental costs of carbon trade and so-called cap and trade policies are meticulously mapped by the

Barcelona-based collective Carbon Trade Watch. See carbontradewatch.org.

10. Klein, *This Changes Everything*, 211–213.

11. See the witness testimony of Muhammad Al-Kashef, representative of Watch the Med, regarding the green warfare PR strategy of the Airbus military industry at the public hearing for comrades past, present, and future versus Airbus at the *Court for Intergenerational Climate Crimes*, public video archive Framer Framed, October 31, 2021.

12. Andrew Stafford, "'Incredibly moving': Birdsong Album of Threatened Birds Beat Abba to No 5 Spot on Australian Music Charts," *The Guardian*, December 10, 2021.

13. Emma Lawrance, Rhiannon Thompson, Gianluca Fontana, et al., "The Impact of Climate Change on Mental Health and Emotional Wellbeing: Current Evidence and Implications for Policy and Practice," *Grantham Institute*, Briefing Paper no. 36, May 2021.

14. As explained by Thunberg in her speech "Our Lives Are in Your Hands" at the Climate March in Stockholm on September 8, 2018; see Greta Thunberg, *No One Is Too Small to Make a Difference* (London: Penguin Books, 2019), 1–5.

15. See Vanessa Nakate, *A Bigger Picture: My Fight to Bring a New African Voice to the Climate Crisis* (London: Pan Macmillan, 2021).

16. Cited in S. Nazrul Islam, *Rivers and Sustainable Development: Alternative Approaches and Their Implications* (New York: Oxford University Press, 2020), 185. See also Daniel P. Corrigan and Markku Oksanen, eds., *Rights of Nature: A Re-Examination* (Abingdon-on-Thames: Routledge, 2021).

17. Cited from Paulo Ciro's project website, *Extinction Claims* (2021); see extinction-claims.com.

18. Cited in Ciro, *Extinction Claims*.

19. Many fossil fuel giants also counter-sue governments through the Energy Charter Treaty, an international agreement that allows for claims for lost revenue due to climate policy. Jennifer Rankin, "Secretive Court System Poses Threat to Paris Climate Deal, Says Whistleblower," *The Guardian*, November 3, 2021.

20. Cited from Olafur Eliasson, *Little Sun* (2012); project website littlesun.org.

21. Referencing a slogan from the climate justice movement, this is also the title of a book proposing an ecosocialist response to the climate crisis: Martin Empson, Ian Angus, Sarah Ensor, et al., eds., *System Change Not Climate Change: A Revolutionary Response to the Climate Crisis* (London: Bookmarks Publications, 2019).

22. On fossil fuel sponsorship in the arts and its resistance, see T. J. Demos, "The Great Transition: The Arts and Radical System Change," in *Beyond the World's End: Arts of Living at the Crossing* (Durham, NC: Duke University Press, 2020), 163–193.

23. Teju Cole, "The White-Savior Industrial Complex," *The Atlantic*, March 21, 2012.

24. During the 2022 COP27 in Sharm-el-Sheikh, the first framework for a "loss and damage fund" to mitigate the impacts of climate catastrophe in the Global South was formed, although the committed sum and operational model of the fund remain unclear, and participating countries did not reach agreement on actual fossil fuel divestment, guaranteeing continued devastating impact on the same countries the fund is supposed to help.

25. See Richard Peet, *Unholy Trinity: The IMF, World Bank and WTO* (London: Zed Books, 2009). See further the strategy document "World Bank Group Climate Change Action Plan 2021–2025: Supporting Green, Resilient, and Inclusive Development," World Bank, Washington, DC.

Chapter 2

1. Duff Hart-Davis, *Ascension: The Story of a South Atlantic Island* (Ludlow: Merlin Unwin Books, 2016).

2. Alex Ritsema, *A Dutch Castaway on Ascension Island in 1725* (Deventer: Alex Ritsema, 2010).

3. Mihnea Mircan, "A Biography of Daphne" (PhD diss., Monash University, 2022), 141–162.

4. Jodi Dean terms this "neofeudalism"; see Jodi Dean, "Neofeudalism: The End of Capitalism?," *Los Angeles Review of Books*, May 12, 2020. See also Yanis Varoufakis on "technofeudalism" in *Another Now: Dispatches from Another Present* (London: Bodley Head, 2020), 145–146, and Yanis Varoufakis, *Technofeudalism: What Killed Capitalism* (London: Penguin Books, 2023).

5. Here I am also referencing the racially troubling book *The Drowned World* by J. G. Ballard, which describes a world wrecked by climate crisis, turned to near uninhabitability, and shifting toward a form of accelerated reversed evolution. J. G. Ballard, *The Drowned World* (London: Fourth Estate, 2014).

6. See also the documentary by Jacob Hurwitz-Goodman and Daniel Keller (dirs.), *The Seasteaders* (2017)—itself a contested work due to Keller's ties to the alt-right leaning LD50 gallery in London.

7. Julia Carrie Wong, "Seasteading: Tech Leaders' Plans for Floating City Trouble French Polynesians," *The Guardian*, January 2, 2017.

8. Refencing James Dale Davidson and Lord William Rees-Mogg's libertarian manifesto *The Sovereign Individual* (1997). See also Sven Lütticken, "Abdicating Sovereignty," in *Propositions for Non-Fascist Living: Tentative and Urgent*, ed. Maria Hlavajova and Wietske Maas (Cambridge, MA: MIT Press, 2019), 81–95.

9. Nicky Woolf, "SpaceX Founder Elon Musk Plans to Get Humans to Mars in Six Years," *The Guardian*, September 28, 2016.

10. Ibid.

11. On SpaceX and the colonial legacy and mentality of space exploration, see Fred Scharmen, *Space Forces: A Critical History of Life in Outer Space* (London: Verso, 2021).

12. As elaborated unapologetically in the series' companion book publication; see Leonard David, *Mars: Our Future on the Red Planet* (Washington, DC: National Geographic Society, 2016).

13. Kimberley D. McKinson, "Lessons from Mars—And Jamaica—on Sovereignty," *Sapiens*, September 21, 2021.

14. On the intersections of science fiction and world-making, see the online video archive of the two-day conference "Realities of Science Fiction," LUMA, Arles, October 23–24, 2021.

15. Naomi Klein, "How Big Tech Plans to Profit from the Pandemic," *The Guardian*, May 13, 2020.

16. Syd Mead, *The Movie Art of Syd Mead: Visual Futurist* (London: Titan Books, 2017).

17. Retrieved from the website of Daan Roosegaarde: studioroosegaarde.net.

18. Nico Daswani, Fumio Nanjo, and Carol Becker, *Daan Roosegaarde in Perspectief* (Eindhoven: Lecturis, 2019).

19. Ted Loos, "Loving Art to the Moon and

Back," *New York Times*, June 23, 2022.

20. Ibid.

21. Femke Herregraven, *Volatility Storms: Investment Portfolio* (2014), part of Serpentine Galleries' online exhibition project *Extinction Sites*. See further Femke Herregraven, "Robotic Arms, Crabs and Algos: The Arctic Ocean Floor as a New Financial Frontier," in *The Geological Imagination*, ed. Lucas van der Velden, Mirna Belina, and Arie Altena (Amsterdam: Sonic Acts, 2015), 213–237.

22. Ibid.

23. Ibid.

24. This is exemplified in the corporate dystopian cult thought known as the "Dark Enlightenment." See Nick Land, "Dark Enlightenment," in *A Nick Land Reader: Selected Writings* (self-published, 2018).

25. The person(s) known as Satoshi Nakamoto published what became known as "The Bitcoin White Paper" on October 31, 2008, through the cryptography mailing list of the website metzdowd.com.

26. Based, in James Bridle's words, on a deeply problematic notion of "trustlessness"; see James Bridle, "Introduction," in Satoshi Nakamoto, *The White Paper* (London: Ignota Books, 2019), v–xxii, xxii.

27. Samantha T. Edgell, "Toto, I've a Feeling the Environment Isn't Safe from Cryptocurrency Anymore: The Degrading Ecological Effects of Bitcoin and Digital Currencies," *Villanova Environmental Law Journal* 32 (2021): 69–89.

28. Ben Davis, "I Looked through All 5,000 Images in Beeple's $69 Million Magnum Opus. What I Found Isn't So Pretty," *Artnet*, March 19, 2021.

29. As Gene Ray writes in facing ecosystem collapse, "What would have been extreme, as words flowing from any mouth in any conversation, will soon be banal." Gene Ray, "Writing the Ecocide-Genocide Knot: Indigenous Knowledge and Critical Theory in the Endgame," *South as a State of Mind* 8 (Fall/Winter 2016): 118–137, 120–121.

30. See the DigitalArt4Climate project website: digitalart4climate.space/.

31. Laura J. Sonter, Marie C. Dade, James E. M. Watson, et al., "Renewable Energy Production Will Exacerbate Mining Threats to Biodiversity," *Nature Communications*, September 1, 2020.

32. Chris Styokel-Walker, "TechScape: Turns Out There's Another Problem with AI—Its Environmental Toll," *The Guardian*, August 1, 2023.

33. See further Natalie Koch, "Whose Apocalypse? Biosphere 2 and the Spectacle of Settler Science in the Desert," *Geoforum* 124 (2021): 36–45.

34. Bannon's direction of Biosphere 2 essentially prefigured the alt-right biosphere he aimed to propagate in his work for the Tea Party movement and, later, for the Trump administration. See Jonas Staal, *Steve Bannon: A Propaganda Retrospective* (Rotterdam: Het Nieuwe Instituut, 2018).

35. Neil Vigdor, "Bezos Thanks Amazon Workers and Customers for His Vast Wealth, Prompting Backlash," *New York Times*, July 20, 2021.

Chapter 3

1. Featured in Daniel J. Clark (dir.), *Behind the Curve* (2018).

2. As proposed in Samuel Rowbotham's *Zetetic Astronomy: Earth Not a Globe*, published in 1849 under the pseudonym "Parallax."

3. Ellen Brait, "'I didn't wanna believe it either': Rapper BoB Insists the Earth Is Flat," *The Guardian*, January 26, 2016.

4. For a historical perspective on the Flat

Earth Society, see Christine Garwood, *Flat Earth: The History of an Infamous Idea* (London: Pan Books, 2010).

5. Referencing the so-called alt-right, see George Hawley, *Making Sense of the Alt-Right* (New York: Columbia University Press, 2017); Angela Nagle, *Kill All Normies: Online Culture Wars from 4Chan and Tumblr to Trump and the Alt-Right* (Winchester: Zero Books, 2017); David Neiwert, *Alt-America: The Rise of the Radical Right in the Age of Trump* (London: Verso, 2017).

6. Its own key "peer reviewed" publication being Craig Idso and S. Fred Singer, *Climate Change Reconsidered* (Chicago: Heartland Institute, 2009).

7. See the report by the Center for Countering Digital Hate, *Pandemic Profiteers: The Business of Anti-Vaxx* (2021).

8. Cited from Mikki Willis (dir.), *Plandemic: The Hidden Agenda behind Covid-19* (2020).

9. Ibid.
10. Ibid.
11. Ibid.

12. This is also the title of a book by World Economic Forum director Klaus Schwab published in the same year; see Klaus Schwab and Thierry Malleret, COVID-19: *The Great Reset* (Cologny: Forum, 2020).

13. Mia Bloom and Sophia Moskalenko, *Pastels and Pedophiles: Inside the Mind of QAnon* (Stanford, CA: Stanford University Press, 2021).

14. On the Querdenken movement and its larger ideological connections, see Sven Lütticken, "Divergent States of Emergence: Remarks on Potential Possibilities, against All Odds," *e-flux Journal*, no. 115 (February 2021).

15. Travis M. Andrews, "She Fell into QAnon and Went Viral for Destroying a Target Mask Display. Now She's Rebuilding Her Life," *Washington Post*, November 11, 2020.

16. Charlotte Ward and David Voas, "The Emergence of Conspirituality," *Journal of Contemporary Religion* 26 (2011): 103–121.

17. According to the German data and statistics company Statista, the worldwide value of the wellness industry in 2019 was $4.4 trillion, projected to grow to $6 trillion by 2025; see Christina Gough, "Wellness Industry—Statistics & Facts," *Statista*, March 15, 2022. McKinsey & Company projected more modest numbers worldwide for 2021, valuing it up to $1.5 trillion; see Shaun Callaghan, Martin Lösch, and Anna Pione, "Feeling Good: The Future of the $1.5 Trillion Wellness Market," McKinsey & Company, April 8, 2021. These results differ depending on which sector branches are considered part of the wellness industry, as well as the interests of the industry itself to include as broad a scope of activities as possible in data research in order to project growth.

18. Gwyneth Paltrow, "GP's Picks: Healing My Body with a Longer-Term Detox," *Goop*, February 2021.

19. Jonathan Nunn, "The 'Sourdough Bro' and Marx: Lockdown Lessons in Trying and Failing to Make Bread," *Prospect Magazine*, May 7, 2020.

20. Gene Ray provides definitions of the prepper in a far-right context, but also proposes what left-wing prepping could or should look like; see Gene Ray, "Left-Wing Prepping: After the Holocene, the Commons," in *Oliver Ressler, Assets Must Be Stranded*, ed. iLiana Fokianaki (Athens: State of Concept, 2022). See further: Gene Ray, *After the Holocene: Planetary Politics for Commoners* (New York: Autonomedia, 2024).

21. On the emergence of self-care in the face

of the loss of collective care infrastructures, see iLiana Fokianaki, "The Bureau of Care: Introductory Notes on the Care-Less and Care-Full," *e-flux Journal*, no. 113 (November 2020).

22. Alex Jones, *The Great Reset: And the War for the World* (New York: Hot Books, 2022).

23. Molly Young, "How Amanda Chantal Bacon Perfected the Celebrity Wellness Business," *New York Times Magazine*, May 25, 2017.

24. Tom Dreisbach, "What Led a Police Chief Turned Yoga Instructor to the Capital Riot," NPR, July 7, 2021.

25. J. F. Black, "The Greenhouse Effect," June 6, 1978, internal report commissioned by Exxon Mobil.

26. See the report "Big Oil's Real Agenda on Climate Change: How The Oil Majors Have Spent $1bn since Paris on Narrative Capture and Lobbying on Climate," *InfluenceMap*, March 2019. See further Jane McMullen (dir.), *Big Oil against the World* (2022).

27. Stuart Parkinson, "The Carbon Boot-Print of the Military," *Responsible Science Journal* 2 (March 2020): 18–20.

28. Neta C. Crawford, "Pentagon Fuel Use, Climate Change, and the Costs of War," *Watson Institute*, November 13, 2019.

29. See the report "The Military Cost of Defending the Global Oil Supply," *Securing America's Future Energy*, September 21, 2018.

30. Lena Klaaßen and Christian Stoll, "Harmonizing Corporate Footprints," *Nature Communications*, October 22, 2021.

31. See the report "Big Tech and Climate Policy," *InfluenceMap*, January 2021.

32. John Vidal, "'Tsunami of Data' Could Consume One Fifth of Global Electricity by 2025," *Climate Home News*, December 11, 2017.

33. Kees Balde and Garam Bel, "Consultation on the Methodology for Measuring the Global Progress of E-Waste Legislation," *Global E-Waste Statistics Partnership*, 2020.

34. Natasha Lennard, "The G7 Upheld Vaccine Apartheid: Officials from the 'Global South' Are Pushing Back," *The Intercept*, June 17, 2021.

35. See Vandana Shiva, *Oneness vs. the 1%: Shattering Illusions, Seeding Freedoms* (Oxford: New Internationalist, 2019).

36. See the report "Last Line of Defense," *Global Witness*, September 13, 2021.

37. Amos Fong, Jon Roozenbeek, Danielle Goldwert, et al., "The Language of Conspiracy: A Psychological Analysis of Speech Used by Conspiracy Theorists and Their Followers on Twitter," *Group Processes & Intergroup Relations* 24 (2021): 606–623.

38. Will Fenstermaker, "Adam Curtis's Theory of Everything," *Dissent* (Summer 2021). On Curtis's conspiracist turn, see Jonas Staal, "Propaganda (Art) Struggle," *e-flux Journal*, no. 94 (October 2018).

39. Mark Dery, "The Professor of Paranoia," *Chronicle of Higher Education*, May 12, 2021.

Chapter 4

1. On the political genealogy of superhero comics, see further Marc DiPaulo, *War, Politics and Superheroes* (Jefferson, NC: McFarland, 2011).

2. Travis Clark, "The Thanos Subreddit Successfully Banned over 300,000 Members in Honor of 'Infinity War,'" *Business Insider*, July 10, 2018.

3. Nadja Popovich and Brad Plumer, "Who Has the Most Historical Responsibility for Climate Change?," *New York Times*, November 12, 2021.

4. Sherronda J. Brown, "Humans Are Not the

Virus: Don't Be an Eco-Fascist," *gal-dem*, April 3, 2020.

5. A term originally coined by Renaud Camus, and elaborated on in *Le grand remplacement* (2011).

6. See Naomi Klein, *On Fire: The Burning Case for a Green New Deal* (London: Penguin Random House UK, 2019), 40–49. See further Andreas Malm and the Zetkin Collective, *White Skin, Black Fuel: On the Danger of Fossil Fascism* (London: Verso, 2021).

7. Oliver Milman, "Climate Experts Call for 'Dangerous' Michael Moore Film to Be Taken Down," *The Guardian*, April 28, 2020.

8. Quoted from Jeff Gibbs (dir.), *Planet of the Humans* (2020).

9. Fred Pearce, "Consumption Dwarfs Population as Main Environmental Threat," *Yale Environment 360*, April 13, 2009.

10. On the correlation between climate crisis and the COVID-19 pandemic, see Andreas Malm, *Corona, Climate, Chronic Emergency: War Communism in the Twenty-First Century* (London: Verso, 2020).

11. Gerda Hooijer and Desmond King, "The Racialized Pandemic: Wave One of COVID-19 and the Reproduction of Global North Inequalities," *Perspectives on Politics* 20, no. 2 (August 11, 2021): 507–527.

12. See also Jonas Staal, "Contagion Propagations," in *Deserting from the Culture Wars*, ed. Maria Hlavajova and Sven Lütticken (Cambridge, MA: MIT Press, 2020), 125–151.

13. Matt Vornell, "Where the Z Stands for Zionism," *Al Jazeera*, July 17, 2013.

14. What Andreas Malm also describes as "lust for extermination"; see Malm, *Corona, Climate, Chronic Emergency*, 35. I address fascist joy specifically in relation to Pier Paulo Pasolini's film *Salò o le 120 giornate di Sodoma* (120 Days of Sodom, 1975); see Jonas Staal, "Staging Them: Entartete Kunst from Past to Present," in *The Aesthetics of Ambiguity: Understanding and Addressing Monoculture*, ed. Pascal Gielen and Nav Haq (Amsterdam: Valiz, 2020).

15. For Immanuel Kant, the sublime manifests through grand and terrifying events in nature that supersede our capacity of comparison: "magnitude that is equal only to itself." Simultaneously, Kant perceives the experience of the sublime as a proof of the human mind's "supersensible" capacity to conceptualize even infinity. See Immanuel Kant, *Critique of Judgement*, trans. Werner S. Pluhar (Indianapolis: Hackett Publishing, 1987), 105, 106.

16. Cited from Roland Emmerich (dir.), *The Day after Tomorrow* (2004).

17. Natasha Daly, "Fake Animal News Abounds on Social Media as Coronavirus Upends Life," *National Geographic*, March 20, 2020.

18. This is literally the narrative structure of David Wallace-Wells's bestseller *The Uninhabitable World* (2019). While not ecofascist in intent, the destructive joy—or lust for extermination—and the degree-per-chapter countdown toward total ecocidal collapse certainly follows the logic of the extinction sublime. See David Wallace-Wells, *The Uninhabitable World: A Story of the Future* (London: Penguin Books, 2019).

19. Ruby Hamad, "Whitewashing the Impossible," *Sydney Herald*, May 16, 2013.

20. Defined by Mbembe as the "*generalized instrumentalization of human existence and the material destruction of human bodies and populations*" (emphasis by author) or, in short, "contemporary forms of

subjugating life to the power of death." See Achille Mbembe, *Necropolitics* (Durham, NC: Duke University Press, 2019), 86, 92.

21. Franz-Josef Brüggemeier, Mark Cioc, and Thomas Zeller, eds., *How Green Were the Nazis? Nature, Environment, and Nation in the Third Reich* (Athens: Ohio University Press, 2005).

22. Abby Aguire, "Octavia Butler's Prescient Vision of a Zealot Elected to 'Make America Great Again,'" *New Yorker*, June 26, 2017.

23. Octavia E. Butler, *Parable of the Talents* (New York: Grand Central Publishing, 2007), 19.

24. Cited from Bong Joon-ho (dir.), *Snowpiercer* (2013).

25. Ibid.

26. Elvia Wilk, *Oval* (New York: Soft Skull, 2019), 76.

27. Ibid., 251.

28. Anupama Arora, "'The sea is history': Opium, Colonialism, and Migration in Amitav Ghosh's *Sea of Poppies*," *ariel: A Review of International English Literature* 42, nos. 3–4 (2012): 21–42.

29. Emmanuel Akinwotu and Weronika Strzyżyńska, "Nigeria Condemns Treatment of Africans Trying to Flee Ukraine," *The Guardian*, February 28, 2022; Lorenzo Tondo, "'I will not be held prisoner': The Trans Women Turned Back at Ukraine's Borders," *The Guardian*, March 22, 2022.

30. What Joseph Masco described as a "a potentially endless recursive loop of threat production and response"; see Joseph Masco, *The Theater of Operations: National Security Affect from the Cold War to the War on Terror* (Durham, NC: Duke University Press, 2014).

Chapter 5

1. This hybrid form seeking for actionability overlaps with Elvia Wilk's critical analysis of Solarpunk: "Solarpunk aims to transform science fiction into science action." See Elvia Wilk, "Is Ornamenting Solar Panels a Crime?," *e-flux Architecture*, "Positions," April 2018.

2. See the US congressional resolution developed by Representative Alexandria Ocasio-Cortez and Senator Edward J. Markey, proposed in both the Senate and House of Representatives on February 7, 2019.

3. This included the exclusion of Black and brown workers from Social Security as well as protections under the National Labor Relations Act in order for the Roosevelt administration to appease Southern Democrats in Congress. See Juan F. Perea, "The Echoes of Slavery: Recognizing the Racist Origins of the Agricultural and Domestic Worker Exclusion from the National Labor Relations Act," Loyola University Chicago, School of Law, *LAW eCommons*, 2011.

4. In response to the social democratic-Keynesian Green New Deal, see Max Ajl's ecosocialist manifesto: Max Ajl, *A People's Green New Deal* (London: Pluto Press, 2021).

5. Cited from Kim Boekbinder and Jim Batt (dirs.), *A Message from the Future with Alexandria Ocasio-Cortez* (2019).

6. As famously argued by Mark Fisher; see Mark Fisher, *Capitalist Realism: Is There No Alternative?* (Winchester: Zero Books, 2009).

7. Cited from Kim Boekbinder and Jim Batt (dirs.), *A Message from the Future II: The Years of Repair* (2020).

8. Ibid.

9. Paraphrasing Fredric Jameson's book title *Archaeologies of the Future: The Desire Called Utopia and Other Science Fictions* (London: Verso, 2005).

10. Naomi Klein, *The Shock Doctrine: The Rise of Disaster Capitalism*

11. See Alice G. Guillermo, *Social Realism in the Philippines* (Manila: Asphodel, 1987), and Alice G. Guillermo, *Protest/Revolutionary Art in the Philippines 1970–1990* (Quezon City: University of Philippines Press, 2001).

12. The Woodbine autonomous cultural hub proposes that mutual aid work during times of governmental failure—like the COVID-19 pandemic—can allow for the development of "disaster confederalism." See Woodbine, "Organizing for Survival in New York City," *Commune*, April 24, 2020. On the anarcho-communist roots of mutual aid in the work of Peter Krotopkin, see Andreas Petrossiants, "The Art of Mutual Aid," *e-flux Architecture*, "Workplace," November 2021.

13. Kim Stanley Robinson, *The Ministry of the Future* (London: Orbit Books, 2020), 229.

14. Ibid., 294.

15. Joep van Lieshout, "Cascade," *Sculpture International Rotterdam*, sculptureinternationalrotterdam.nl/, accessed September 2023.

16. Ibid.

17. Extinction Rebellion, *This Is Not a Drill: An Extinction Rebellion Handbook* (London: Penguin Random House UK, 2019).

18. Cited from personal conversation with Maria Hlavajova, March 5, 2020.

19. Wretched of the Earth, "An Open Letter to Extinction Rebellion," *Red Pepper*, May 3, 2019. See also Out of the Woods, "Extinction Rebellion: Not the Struggle We Need, Pt. 1," libcom.org, July 19, 2019.

20. XR has proven responsive to this critique in their ongoing elaboration of ten principles. See Extinction Rebellion, "Our Principles," extinctionrebellion.uk/.

21. See Andreas Malm, *How to Blow Up a Pipeline: Learning to Fight in a World on Fire* (London: Verso, 2021).

22. Cited from Benedikt Erlingsson (dir.), *Woman at War* (2018).

23. Isabelle Fremeaux and Jay Jordan, *We Are "Nature" Defending Itself* (London: Pluto Press, 2021), 21.

24. Ibid., 86.

25. Ibid., 34.

26. Ibid., 86.

27. Sandi Hilal and Alessandro Petti, *Refugee Heritage* (Stockholm: Art & Theory Publishing, 2021).

28. Fremeaux and Jordan, *We Are "Nature" Defending Itself*, 118.

29. On the intersection between colonial empire and dominant science fiction narratives, see John Rieder, *Colonialism and the Emergence of Science Fiction* (Middletown, CT: Wesleyan University Press, 2008).

30. Alexandra Alter, "'We've already survived an apocalypse': Indigenous Writers Are Changing Sci-Fi," *New York Times*, August 14, 2020.

31. See further J. R. Miller, *Shingwauk's Vision: A History of Native Residential Schools* (Toronto: University of Toronto Press, 1996).

32. See also Jason Edward Lewis, Noelani Arista, Archer Pechawis, and Suzanne Kite, "Making Kin with the Machines," *Journal of Design and Science*, July 16, 2018.

33. Gerald Vizenor, *Manifest Manners: Narratives on Postindian Survivance* (Lincoln: University of Nebraska Press, 1994), vii.

34. The Red Nation, *The Red Deal: Indigenous Action to Save Our Earth* (Brooklyn: Common Notions, 2021), 5.

35. Nick Estes, "What the Coup against Evo Morales Means to Indigenous People like Me," *The Guardian*, November 14, 2019. See also Sven Harten, *The Rise of Evo Morales and the MAS* (London: Zed Books, 2011).

36. The Red Nation, *The Red Deal*, 12.

37. See the rebuttal to the EU's Green New Deal: Greenpeace European Unit, "European Green New Deal Misses the Mark," *Greenpeace*, December 11, 2019.

38. The Red Nation, *The Red Deal*, 23. See also Winona LaDuke, "Cannibal Economics: Why the Black Snake Will Eventually Eat Itself," *In These Times*, December 9, 2017.

39. The Red Nation, *The Red Deal*, 39.

40. Ibid., 23.

41. Not an Alternative, "Beneath the Museum, the Spectre," in *The Routledge Companion to Contemporary Art, Visual Culture, and Climate Change*, ed. T. J. Demos, Emily Eliza Scott, and Subhankar Banerjee (Thames: Routledge, 2021), 418–427, 424.

42. Lyons and Jones, "Towards a Theory of Red Natural History."

43. Not an Alternative, "NAA Convention 2015," *The Natural History Museum*, 2015.

44. Sarah Cascone, "Scientists Tell Natural History Museums to Shun Billionaire Donor and Climate Change-Denier David Koch," *Artnet*, March 25, 2015.

45. Lyons and Jones, "Towards a Theory of Red Natural History."

46. Ibid. This is paraphrased from Glen Sean Coulthard, *Red Skin, White Masks: Rejecting the Colonial Politics of Recognition* (Minneapolis: University of Minnesota Press, 2014), 13.

47. See also Charl Landvreugd's symposium "Imagining Liquidification," Stedelijk Museum, Amsterdam, March 26, 2022.

48. Also referred to by Landvreugd as "Afropean." See Charl Landvreugd, "Notes on Imagining Afropea," *Open Arts Journal*, no. 5 (Summer 2016): 39–52.

49. See also Jonas Staal, "Charl Landvreugd's 'Movt. Nr. 10: Ososma,'" *Art Agenda*, December 4, 2019.

50. Elaborated in the performative event by Charl Landvreugd, *The Utopia of the Normal Space*, Brakke Grond, Amsterdam, September 19, 2021.

51. See Zayaan Khan, "Ancient Futures," in *Training for the Future Handbook*, ed. Florian Malzacher and Jonas Staal (London: Sternberg Press, 2021), 108–141.

52. Jeff VanderMeer, *Annihilation* (London: Fourth Estate, 2015), 173, emphasis by the author.

53. Donna Haraway, *Staying with the Trouble: Making Kin in the Chthulucene* (Durham, NC: Duke University Press, 2016), 58.

54. MELT (Ren Loren Britton and Isabel Paehr), *Con(fuse)ing and Re(fusing) Barriers*, *APRJA* 10, no. 1 (2021): 71–82.

55. MELT (Ren Loren Britton and Isabel Paehr), *MELTING MANIFESTO*, meltionary.com.

56. Ibid.

57. The notion of the construct family is central to Butler's *Xenogenesis Trilogy* (1987–1989), in which humans encounter the "gene-trader" species Oankali, which can genetically mutate what it considers the "human contradiction," namely, the combination of "intelligence and hierarchical behavior." As a result, new interdependent, construct families emerge with both Oankali and human members. Octavia E. Butler, *Lilith's Brood* (New York: Grand Central Publishing, 2007), 442. See also Antonia Majaca and Luciana Parisi, "The Incomputable and Instrumental Possibility," *e-flux Journal*, no. 77 (November 2016).

58. Octavia E. Butler, *Parable of the Sower* (New York: Grand Central Publishing, 2007), 3.

59. Jem Bendell, "Deep Adaptation: A Map for Navigating Climate Tragedy," Institute of

Leadership and Sustainability (IFLAS), University of Cumbria, July 27, 2018.

Afterword

1. Alexis Pauline Gumbs, *Undrowned: Black Feminist Lessons from Marina Mammals* (Edinburgh: AK Press, 2020).

2. See Haraway, *Staying with the Trouble*, 104–116.

3. And, as Anna Lowenhaupt Tsing narrates, these stories of resisting the various ends of the world are waged not just by humans, but in symbiotic relationship with nonhuman earth workers—like her protagonist, the Matsutake mushroom. See Anna Lowenhaupt Tsing, *The Mushroom at the End of the World: On the Possibility of Life in Capitalist Ruins* (Princeton, NJ: Princeton University Press, 2015).

4. As Jodi Dean has written, comradeship is "characterized by equality and belonging, by a love and respect between equals so great that it can't be contained in human relations but spans to include insects and galaxies (bees and stars) and objects themselves." Dean, *Comrade*, 65.

5. Cited in Ama Biney, "Madmen, Thomas Sankara and Decoloniality in Africa," in *A Certain Amount of Madness: The Life Politics and Legacies of Thomas Sankara*, ed. Amber Murrey (Pluto Press, 2018), 142.

6. Abdullah Öcalan, *The Political Thought of Abdullah Öcalan: Kurdistan, Women's Revolution and Democratic Confederalism* (London: Pluto Press, 2017).

7. J. G. Gehling and P. Vickers-Rich, "The Ediacara Hills," in *The Rise of Animals: Evolution and Diversification of the Kingdom Animalia*, ed. Mikhail A. Fedonkin, James G. Gehling, et al. (Baltimore: Johns Hopkins University Press, 2007), 89–113, 92.

8. Andrew H. Knoll, Malcolm R. Walter, et al., "The Ediacaran Period: A New Addition to the Geological Time Scale," *Lethaia* 39 (2006): 13–30.

9. Mark A. S. McMenamin in *The Garden of Ediacara: Discovering the First Complex Life* (New York: Columbia University Press, 1998).

10. Quoted from Stephen Gilchrist, "Everywhen: The Eternal Present in Indigenous Art from Australia," in *Everywhen: The Eternal Present in Indigenous Art from Australia*, ed. Daniel Kirby and Georgina Rayner (New Haven, CT: Yale University Press, 2016), 18–31, 25.

© 2024 Massachusetts Institute of Technology

All rights reserved. No part of this book may be used to train artificial intelligence systems or reproduced in any form by any electronic or mechanical means (including photocopying, recording, or information storage and retrieval) without permission in writing from the publisher.

The MIT Press would like to thank the anonymous peer reviewers who provided comments on drafts of this book. The generous work of academic experts is essential for establishing the authority and quality of our publications. We acknowledge with gratitude the contributions of these otherwise uncredited readers.

This publication was made possible, in part, through the support of BAK, basis voor actuele kunst, Utrecht, the Netherlands.

bak

This book was set in Haultin by the MIT Press. Printed and bound in the United States of America.

Library of Congress Cataloging-in-Publication Data

Names: Staal, Jonas, 1981– author.
Title: Climate propagandas : stories of extinction and regeneration / Jonas Staal.
Description: Cambridge, Massachusetts : The MIT Press, [2024] | Includes bibliographical references.
Identifiers: LCCN 2023059552 (print) | LCCN 2023059553 (ebook) | ISBN 9780262549820 (paperback) | ISBN 9780262380867 (epub) | ISBN 9780262380874 (pdf)
Subjects: LCSH: Communication in politics—Comparative method. | Climatic changes—Political aspects. | Environmentalism—Political aspects. | Petroleum industry and trade—Political aspects. | Petroleum industry and trade—Social aspects. | Extinction (Biology)—Social aspects. | Extinction (Biology)—Environmental aspects.
Classification: LCC JA85 .S72 2024 (print) | LCC JA85 (ebook) | DDC 304.2/8—dc23/eng/20240412
LC record available at https://lccn.loc.gov/2023059552
LC ebook record available at https://lccn.loc.gov/2023059553

10 9 8 7 6 5 4 3 2 1